Mennonites OF SOUTHERN ILLINOIS

Mennonites
OF SOUTHERN ILLINOIS *A Photographic Journal*

Jane Flynn WITH FOREWORDS BY HERBERT K. RUSSELL AND LIZ WELLS

Southern Illinois University Press Carbondale

Southern Illinois University Press
www.siupress.com

Copyright © 2024 by Jane Flynn
All rights reserved
Printed in the United States of America

27 26 25 24 4 3 2 1

Cover illustration: Figures 18 (*top left*), 24 (*bottom left*), and 40 (*right*) by author. Beige textile background (tinted) by Da-ga, Adobe Stock #46411409.

Publication of this volume has been made possible in part through a generous contribution by Marlin Jeschke, professor emeritus of philosophy and religion, Goshen College

This book has been catalogued with the Library of Congress.
ISBN 978-0-8093-3940-2 (paperback)
ISBN 978-0-8093-3941-9 (ebook)

Printed on recycled paper ♻

SIU
Southern Illinois University System

*To the Mennonites of southern Illinois;
thank you and God bless you!*

For God so loved the world, that he gave his only begotten Son, that whosoever believeth in him should not perish, but have everlasting life.

John 3:16

Table of Contents

xi	Foreword HERBERT K. RUSSELL
xvii	Foreword LIZ WELLS
xxi	Preface
xxvii	Acknowledgments
1	Photographs
117	Notes
119	Bibliography

Foreword

These photos of Mennonite life were taken between 2014 and 2020 in the Ozarks of southern Illinois. Mennonite farm families arrived here in 1960 in search of a place where they could pursue a quiet, rural lifestyle and raise their children in the Mennonite faith. The immediate cause of their settling here was the prohibitive cost of rural land elsewhere, but their story is a long one, beginning five centuries ago in Europe during the turbulent years of the Protestant Reformation.

The Reformation began in 1517 when the German Catholic priest Martin Luther publicly objected to his church's selling of "indulgences" (whereby sins were said to be forgiven through donations). Luther had merely wanted to reform this and certain other practices, but his protests led to an entirely new branch of Christianity—Protestantism—and a new religious body that bore his name, the Lutheran Church.

A decade later, in 1527, England's Henry VIII was searching for legal or religious means to rid himself of a wife who bored him and (more dangerous for her) had failed to produce a viable male heir. Henry's concerns about this, his political executions, and the religious dissidence in Europe resulted in a second new Protestant group, the Church of England, in 1534.

Both Protestant churches behaved much like the Catholic in that they regarded those who believed

differently as heretics. In an age when church and state were joined (the name of the Church of England is an excellent example), it was all too easy for men and women to be tried for heresy or treason, punishment for which included burning alive, beheading, drowning, and hanging. Catholics persecuted Protestants, Protestants persecuted Catholics—and they would both persecute Mennonites.

A central question of those years concerned the proper age for people to be baptized. At a time when a third of European children died before age five, infant baptism seemed sound theology. Others felt baptism should be reserved for those old enough to choose to be baptized, and this too seemed sound. Those who favored later or adult baptism were labeled *Anabaptist*s, the re-baptizers. (The name assumed that many of these would have been baptized as infants, hence re-baptism.) The Anabaptists did not make up a separate denomination but were a fissiparous collection of Protestants whose identity derived from their leaders and practices: Mennonites, Hutterites, Amish, and Dunkers (or Brethren).

Mennonites had their beginnings in 1536 in the Netherlands when the Catholic priest Menno Simmons grew weary of Europe's endless wars and church rituals for which he could find no biblical basis and made the heretical statement that combining statecraft and theology created many of humankind's problems. He was a pacifist—but in the sixteenth century merely suggesting the separation of church and state threatened the leaders of both institutions. Menno Simmons spent the rest of his life on the run and was still a wanted man when he died in 1561, but he had lent his ideals and name to the like-minded, the *Mennonites*.

Mennonite fortunes changed for the better in the seventeenth century when opportunities opened in the New World in the British colony managed by William Penn. Penn had a genius for combining his Quaker religion with entrepreneurship and encouraged people to migrate to Penn's Sylvania (or woods), a vast tract of land given him by England's Charles II (who had owed money to the Penn family). William Penn established good relations with Native Americans, promoted religious tolerance, and traveled to Europe to recruit settlers to immigrate. In 1683 a group of Mennonites migrated to lands near present-day Philadelphia and began a century-long breath of religious freedom.

These early Mennonites came mostly from Germany and Holland and settled in Lancaster County in an area they named Germantown. Similar groups followed, including the followers of Jakob Ammann. Ammann himself remained in Europe but lent his name to a conservative offshoot of the Mennonites, the Amish, some of whom—Amish Mennonites (about whom more below)—represent a meld of both groups.

They spoke German at home, limited their interactions with outsiders, worked as farmers and craftspeople, and practiced frugality and pacifism. Like the Quakers, they adopted the modest attire that earned them the nickname *plain people*. They endeavored to live according to the Bible's John 17—to be in the world but not of it—and found in Pennsylvania the rural and religious harmonies they had sought in Europe: *de still im lande*, the quiet in the land.

When the Revolutionary War ended in 1783, some Mennonites began leaving Pennsylvania in search of new land and opportunities elsewhere. Throughout the nineteenth century, they made their way into the agricultural areas of the Midwest, arriving in Illinois in the 1830s and settling mostly in central and northern Illinois. They moved on when high land prices and scarcity of acreage indicated it was time to look further.

When they moved, their values and traditions moved with them: long hair and head coverings for women; beards on married men; and simple and practical

clothing for all. They eschewed displays of vanity, observed the Sabbath day as holy, married within the church, and regarded children as gifts from God. They were strongly against divorce and avoided alcohol, tobacco, and politics. Baptism was administered to those old enough to choose it, and their leaders were all men. Like Menno Simmons, they were pacifists.

The American Civil War did not greatly test the pacifism of most Illinois Mennonite men since nearly all of the state's soldiers were volunteers. But when the United States went to war with Germany in World War I, anti-German sentiment and slogans swept the country. German-speaking churches and parochial schools felt the suspicions of their neighbors, use of the German language was curtailed, and everyone was expected to buy war bonds to "Halt the Hun." Given the temper of the times, it now seems surprising that the American military allowed pacifists to choose noncombat service.

Guidelines for pacifists had been further liberalized by the beginning of World War II, but the end of that war ushered in an economic boom that made itself felt in rural areas by 1950. Farm tractors (their production delayed by the need for war materials) arrived in numbers, and many horses were retired to permanent pastures. Pickup trucks replaced the small carts pulled behind tractors or (less often) cars, and they rode on improved roads flanked by poles carrying electricity. Progress was encroaching on the Mennonite dream of an American Arcadia.

Through the late 1940s, many rural Illinois students had walked along dirt roads to country schools that dotted downstate. They deposited lunch buckets in the cloakroom, drank water with a dipper at a bucket, and, as often as not, learned the same lessons their parents had. Education typically ended after eighth grade. By the 1950s, however, many country schools were closing. Fleets of yellow school buses now made their way along all-weather roads to pick up farm children at their mailboxes and carry them to bigger schools in town—to hot lunch programs, new acquaintances, and new curricula and away from the slow-moving rural certainties of the horse-and-buggy days.

Some central Illinois Mennonites addressed changing times and threats to their lifestyle by scouting lightly developed areas in the Illinois Ozarks. This hilly region of southern Illinois runs from the Ohio River to the Mississippi and lies well south of the flatlands leveled by Ice Age glaciers. The Illinois Ozarks were so rugged, rocky, and unencumbered by industry that parts of it were approved as a national forest in 1933. By the 1950s, the enveloping quietness of the Shawnee National Forest zigzagged around thousands of privately owned farms, a half-dozen hilltop county courthouses, and Main Street businesses catering to rural life. Some villages had one stoplight while others had none, and nearly all businesses were closed on Sundays.

Details of the Mennonite arrival here are found in the *Mount Pleasant Mirror, 1966–2010: A Pictorial History of the Mount Pleasant Mennonite School*:

> In the late 1950's, a number of meetings were held across the nation . . . in the interest of "evangelization by colonization." . . . The goal of the meetings was to develop an interest in having a number of families move into an area where there was no Mennonite church. It was an effort by conservative Mennonites to spread the gospel to new communities while being self-supporting. After some deliberation, it was decided that Vienna, Illinois, would be a good place to begin a church. Mennonites from Arthur, Illinois, had first seen the area when they came here in interest of purchasing some advertised livestock. In February and March of 1960, three families moved into the area.

A short time later, these and others created the Mount Pleasant Mennonite Church a few miles west of Vienna near the hamlet of Mount Pleasant in Union County. They were guided then as now by the *Statement of Christian Doctrine and Rules and Discipline of the Eastern Pennsylvania Mennonite Church and Related Areas*. Its language nods to the simplicity of their American beginnings near Philadelphia.

But the Mount Pleasant Mennonites were not the first "plain people" to live here. In 1808—when Illinois was still a part of Indiana—a family of Quakers had settled in what became western Johnson County and eastern Union County, as the Illinois governor-historian John Reynolds noted: "A family of Quakers from North Carolina of the name of Stokes settled [here] in 1808." They gave their name to Stokes Township and set the tone for religious tolerance that manifested itself when ministers of rival faiths met there about 1816. Preacher Jones was a Baptist; George Wolf was a Dunker. They agreed not to compete with one another but to work together in union—and Union County was thus named.

In many respects, the Illinois Ozarks would seem to be just right for the Mennonites in their long search for "the quiet in the land." But here as elsewhere, they have evolved in ways to meet the challenges of changing times:

> *Traditional* Mennonites have tried to maintain their horse-and-buggy, non-industrialized ways by relying on manual labor, wearing traditional farm garb, and making minimal or modified use of mechanized equipment.
>
> *Assimilated* Mennonites are more likely to pursue higher education, are receptive to new technologies, wear the same fashions as the public at large, and are more likely to be employed in urban areas.

Since the 1950s, the peaceful quietude of the Illinois Ozarks has continued to attract Anabaptists. Both Amish and Mennonites make their homes here along with a blend of the two groups—Amish Mennonites. Two Amish Mennonite congregations from Kentucky and Tennessee settled in 1991 on the north slope of the Illinois Ozarks near the villages of Carrier Mills and Stonefort. Amish Mennonites tend to be more progressive than traditional Amish, but there is no easy categorization of Amish Mennonites or other modern Anabaptists as all are likely to continue to adapt to changing times while retaining the basics of their faith. Some congregations still use German in church services. Some drive automobiles, and some do not.

Jane Flynn's photos document the present lifestyles of southern Illinois Mennonites. As they choose between the rustic and the modern, they are faced with an overriding question: How does one balance the tenets of religious teachings with the tools and talents needed to make a living?

HERBERT K. RUSSELL

BIBLIOGRAPHY

Hendrix, Scott H. *Martin Luther: Visionary Reformer* (New Haven: Yale University Press, 2015), 186. No mention of infant baptism in New Testament.

Kraybill, Donald B. *Concise Encyclopedia of Amish, Brethren, Hutterites, and Mennonites* (Baltimore: Johns Hopkins University Press, 2010), 54, 98, 137. Traditional and assimilated Mennonite behavior.

Perrin, William Henry, ed. *History of Alexander, Union and Pulaski Counties, Illinois*. (Chicago: Baskin, 1883), 286–88. Ministers Jones and Wolf.

Reynolds, John. *The Pioneer History of Illinois*, 2nd ed. (Chicago: Fergus Printing, 1887), 386. Stokes, "A family of Quakers."

Smith, Willard H. *Mennonites in Illinois* (Scottdale, Pa.: Herald Press, 1983), 14, to Illinois in 1830s; 458, Mount Pleasant congregation.

Steiner, Sam. "Carrier Mills Amish Mennonite Church (Stonefort, Illinois, USA)." *Global Anabaptist Mennonite Encyclopedia Online.* January 2018; accessed June 8, 2019. http://gameo.org/index.php?Title=Carrier_Mills_Amish_Mennonite_Church_(Stonefort,_Illinois,_USA)&oldid=160373.

Weaver, David H. "Mount Pleasant Mennonite Church History." In *Mount Pleasant Mirror, 1966–2010: A Pictorial History of the Mount Pleasant Mennonite School*. Written and compiled by the 9th and 10th grade students at the Mount Pleasant Mennonite School. Dongola, Ill.: Mount Pleasant Mennonite School, 2010.

Weaver-Zercher, David L. *Martyrs Mirror: A Social History*. Baltimore: Johns Hopkins University Press, 2016), 4, infant mortality; 274–75, World War I and World War II.

Foreword

Ten large melons rest on a small wooden table in the shade of nearby vegetation. The one in the foreground has a dappled skin that is curiously light relative to the other melons. Its neighbor has a couple of dry patches on its exterior, indicating the domestic "homespun" nature of this group. They have been planted and nurtured to feed the local community. The system is utterly different from agri-industrial production. The photograph is shot close-up, in black and white, so we cannot see the greens of the fruits, but the picture invokes smell and taste in a way that melons sold in supermarkets, precut and plastic-wrapped, cannot suggest.

 This evocation emerges in part through the context of viewing the image. It stands alone as a carefully framed picture. But it is intended to be viewed as part of a larger series, a photographic journal, within which farming for communal benefit is one of several aspects of rural life and plain living documented. In *Mennonites of Southern Illinois,* Jane Flynn suggests a rural area that is traditional, farm-based, and relatively untouched by modernity. That the first image is of a church sign indicates the Christian-centered scenario. The land is worked by hand with minimal industrial intervention, and the community is highly self-contained. Flynn's decision to use black and white—that is, an older style of photography—emphasizes the traditional. There is a

sense of repetition and timelessness. We know that the harvest will be more or less plentiful in any one year, that seeds will be saved for sowing the following year, and that food will be routinely harvested and celebrated.

Religious communities living outside mainstream or dominant culture in the United States are not uncommon. We are reminded that, as a result of religious persecution, the Pilgrim Fathers and their families, who were Puritans, Protestants of a particular sect, left Europe for the United States. They landed in what became termed "New England." Over a hundred years later, likewise seeking religious freedom, the Shakers embarked from Liverpool in 1774. This was a small movement; at its height about five thousand members spread across twenty villages and eight states. In the 1980s, when Ann Chwatsky photographed the Shakers of Sabbathday Lake, Maine, only two Shaker communities remained there.[1] Perhaps because New England is less off the beaten path and because American folk museums include their furniture and artifacts in collections, the Shakers are relatively familiar to the general population. Jane Flynn tells us that the Mennonites arrived in America on October 6, 1683, just over sixty years after the landing of the *Mayflower*. Although they first settled in Pennsylvania, they subsequently spread widely; Mennonite communities can be found in most areas of the United States, as well as in Canada and South America. Yet, they have attracted less attention, perhaps because they are dispersed.

Within the history of photography, there are many examples of itinerant observers engaging with everyday phenomena that may be so familiar to those involved that they no longer notice features of their lifestyle and environment. Famously, soon after moving from Switzerland, Robert Frank set about exploring the United States, producing poetic pictures that became *The Americans* (1958).[2] His work was acclaimed for its focus on the everyday and for direct, close-up observations of people, objects, and situations. Jane Flynn is Scottish, likewise an outsider to the United States. She moved to America to study at Southern Illinois University Carbondale, where the course Small Town Documentary formed part of her graduate program in photography. It was in this context that she encountered and became interested in documenting local Mennonite communities. Her approach was very different from Frank's. She spent time in one place, talking with individuals and using photography as a means of reflecting on what appears as an antiquated way of life.

Flynn's photographs are carefully composed to center her subjects. They are captioned in a clear, direct manner. She shot on film to ensure high-quality pictures, selecting cameras of varying formats according to the pictorial and technological demands of the thematic subsections of the series. There is a conceptual integrity of process; using digital cameras would have been out of keeping with the low-tech scenarios that form her subject matter. Additionally, film requires a more reflective approach, pre-conceptualizing images before exposing them. Each frame counts! There is no delete button, nor is there an extensive digital memory allowing for an accumulation of shots to be edited subsequently. The qualities of film, an older mode of picture making, contribute to conveying a sense of the traditional character of the Mennonite society depicted.

Historically, there are numerous examples of photographic documentation of communities that are geographically or culturally isolated from the mainstream and whose members carry on their lives relatively unnoticed and unaffected by broader sociopolitical developments. Such isolation may occur through choice or through circumstances—for instance, island groups. One characteristic tends to be that the culture and values of a particular group or place are slow to change. This is

not exclusive to church-based communities, but faith is often a factor. For the Mennonites, religious belief is central to all community activities, including an emphasis on labor and self-sufficiency and, of course, family roles and hierarchies.

When images are shared with their subjects, photography also operates as a means of showing a community to itself, thereby inviting pause for reflection or discussion on the part of those involved. Additionally, relatively isolated communities and lifestyles can be brought to broader attention, allowing those unfamiliar with a locality and lifestyle to consider the implications of cultural differences. Flynn's images reveal that craft skills are clearly central within the community; we see a fabric shop, a woman quilting, and simple wood furniture. There are some concessions to the contemporary era; one photograph in the fabric store shows a computer-operated embroidery machine and an old-style electric air conditioning/heating unit. Living simply is a matter of choice, not one of necessity, although this emphasis on craft skills, working with one's hands, is biblical (Flynn cites Psalm 90:17).

Living apart from broader cultural currencies is also a matter of choice, or at least a matter of following the teachings and the leadership of senior figures within a community. For instance, Mennonites do not participate in political processes. This means that they choose not to exercise their democratic right to contribute to the selection of representatives in Senate or Congress or, indeed, of the president, although they are still subject to legislation enacted by those for whom they do not vote. The rationale underlying this is trust in God as the greater power and controller of destiny. It follows that they opt out of debates such as those around climate change or energy resources, although they are subject to the consequences of political decisions made. Although they are not necessarily living off the grid, they are unlikely to be heavy energy users given a functionalist, necessity-only attitude to car transport and consumer goods. But they are still subject to the consequences of environmentally related decisions by others.

How much of this can we tell from the photographs? Perhaps not much, particularly regarding many aspects of their beliefs that might arouse our curiosity. But we respond to indications. We see power lines, suggesting the presence of energy supplies. We notice that there are very few cars and that those that are present are somber in color and functional in design. Schooling is based on blackboards, books, and flash cards rather than on videos and computer screens. There is no evidence of television or radio. Indeed, from the pictures, it is not possible to discern by what means information about the world external to the village is gleaned, if it is at all. Following the influence of historical movies, we might assume that news is brought home by word of mouth when anyone rides into town for supplies, but this is an assumption, not a matter of pictorial evidence.

Photographic series tell stories about people, places, and activities. We make sense of such stories through reference to what we know, through what seems familiar. As Estelle Jussim has remarked, we look at clues from the "then" of history (or, it might be added, the "there" of geography) with the eyes of here and now, "the intellectual apparatus of today."[3] Everyday items and familiar situations within specific cultural circumstances may appear strange, quaint, or inexplicable when viewed in an utterly different context. Photographs offer information, but meaning and interpretation are fluid. For instance, as viewers and outsiders, it is tempting to interpret scenes and relations stereotypically. For photographers, one of the challenges is to transcend this tendency, to offer particular and sensitive insights into circumstances and to find a means of conveying a sense of values inherent in a community such as the one Flynn

has explored. The eloquence perhaps lies in the simple statements offered in each image: here is the watermelon harvest; here are rows of books of songs of praise or Bible tracts; here are traditional crafts, whether butchery, beekeeping, or quilting. Look at how people dress! Observe the body language of individuals or groups posing for the camera!

 This is, of course, a unique example, a specific community and lifestyle cohering around a particular set of beliefs and values that, as our experience of the images accumulates, comes to be relatively clear. But, as is often a question for documentary photography, what is the relation between the particular and the general? Is there a broader significance? If so, what resonates here that invites reflection on what is valued, or discounted, in contemporary America?

<div style="text-align: right;">LIZ WELLS</div>

Preface

I was introduced to photography at fifteen and quickly realized the camera's potential as a tool to enter into other worlds. The camera became a means to feed my relentless curiosity about those different from myself and a way to deflect attention from myself while doing so. A native of Scotland, where I spent my first twenty-one years, I have always had a particular interest in the United States—its history, the extremes of its politics, and its standing as a land of unbridled capitalism. Whether it be from the media's representation or just plain curiosity, I always remember as a youngster being positively captivated by the vernacular peculiarities of the American way of life, so being offered a place in an MFA course at Southern Illinois University was a dream come true. My fascination with the people of southern Illinois was something that immediately became obvious through my photography. The class in which that was most apparent was Professor Dan Overturf's Small Town Documentary; in that class I chose to document the town of Stonefort, which is where I first came to meet the Mennonites. My first interactions with the Stonefort/Carrier Mills community set in motion what has since become a deep interest in and reverence for practicing Anabaptists (a Christian movement that the Mennonites and Amish and several other groups are a part of).

Many would claim the southern Illinois region to be generally very politically conservative, and I would somewhat agree. However, there is also some fairly extreme diversity within the area, with a large international student population in Carbondale. The more politically conservative find themselves neighbors with many who consider themselves more liberal. The Mennonites would identify themselves as conservative Christians, upholding the doctrines of nonconformity, nonresistance to evil, believer's baptism, and separation of church and state. Yet as members of the kingdom of God, they do not actively participate in politics or serve in any capacity that is not in harmony with 2 Corinthians 6:14–18 and Romans 13:1–4. Since their arrival to America in 1683,[1] settling in what is now recognized as Pennsylvania, they have spread out to almost all fifty states, living also in Canada and South America.

The Mennonites, or "plain people," as they refer to themselves, took as much interest in my presence in their community as I did in their presence in the larger community of southern Illinois. Despite having grown up in vastly different circumstances, our sharing of memories and stories of our home countries, of our different traditions, and of our different lifestyles became foundational in the development of relationships and subsequent friendships and my photographic representation of them. The resulting photographs are an intimate document of my experiences and relationships that developed over the past nine years spent to date with Mennonites in two small rural communities, but principally in and around Mount Pleasant. The imagery, however, should not be considered as a complete documentation of all things Mennonite. While all Mennonites are Anabaptists, different churches have varying practices concerning certain biblical principles. An example of this would be photography: members of the Stonefort/Carrier Mills allowed me to photograph their businesses and themselves at work; they would not, though, pose before my camera for a family portrait. Additionally, all of their daily discourse and church services are spoken in various forms of German, which further hampered my access to the community and church services. As such, the majority of my relationships and friendships were made within the Mount Pleasant community, whose members speak English within the home and church services.

The traditional practices of gender roles also had a significant influence on what I, as a woman, could and could not access within the community. According to Mark 10:1–12, women are considered subservient to men, and when married they serve their husbands. God, then man, and then woman is considered the order of headship, per biblical teachings. Women are highly respected for their domestic roles, working within the home once they are married, where it is not unusual to have as many as ten children; all children, regardless of their abilities, are considered gifts from God and are lovingly welcomed into the community. Those unable to bear their own children will often adopt from outside the community and raise sons and daughters as all Mennonite children are raised. Like all youth, they will then decide at an appropriate age whether to be baptized, and at baptism they officially join the church. Biblical gender roles are taught to children from a young age; girls will usually work within the home, while boys may have chores on the farm or help their fathers. By the time children are old enough to walk and talk, boys will be sitting with their fathers and girls with their mothers in church and social settings. When socializing in groups, women will usually interact together with their young children or babies, and the men and boys will sit and interact in a different area. These gender roles have influenced what I have and haven't had access to; for instance, I found myself largely socializing and working

alongside women and children but never within groups of men. To view the imagery is to view many (but not all) of my personal experiences of being present in a conservative Christian community that upholds biblical values and practices of gender identity.

By acting in line with members' practices and principles, I have been graciously accepted into their community. I did not want to push worldly practices onto the community, in a vain effort to document areas where lone women would not have otherwise been present, and as such the work reflects experiences from my female-oriented presence. The comfort my subjects had in front of my lens was a direct result of my being so accepted into their ranks, which in turn was a result of not putting my subjects in an uneasy position or pushing their social roles and boundaries; to do so would have undoubtedly produced images very different from the ones you see in this book.

My first experience of this acceptance was when I attended church at Mount Pleasant, having been invited following an interview with the minister, whom I met at a street meeting on the Southern Illinois University campus. Upon entering the church on my initial visit, I was immediately struck by everyone's kindness; many people introduced themselves to me, and I was asked whether I would like to sit next to various women. Although in worldly apparel and appearing distinctly different from the women whom I sat among, I was genuinely welcomed into the service, as all guests are. That Sunday morning I was—and I continue to be—warmly received into their church, their homes, and their businesses.

Periodically throughout the year, there are opportunities for the women to sign up to serve lunch in their homes after the church service. Guests to the service (who may have traveled from many miles away) are invited, alongside friends and family from the church congregation. On my third visit to the Mount Pleasant church, I was invited to lunch by Wanda Weaver, who is depicted with her husband, Glen, on page 41, and whom I have been close with since our first encounter that Sunday. After everyone ate, the women bustled around the kitchen; dishes were washed, dried, and put away, while the table was returned to its original size by removing all the extra leaves and chairs added to accommodate the many guests. After tidying up, the women sat down to visit in the living room. Wanda and I sat together, discussing various aspects of our lives. I asked her how many children she had. Ten! That was the first time I knowingly met anyone who had raised ten children. They are all now grown and live throughout different states. She shared with me a book on the Scottish landscape that she found in a thrift store, and I was able to identify many of the places depicted. She had many questions about life in the UK and expressed her concern for me, living without any family nearby should I need any help or become unwell, so she wrote down her and Glen's contact information on a slip of paper that I still, to this day, keep in my wallet. When I write to her and Glen, I still get out that small slip to refer to their address. That seemingly small gesture of reaching out to me and offering assistance with anything should I need it was heartwarming; it was a level of acceptance and kindness I had not ever come across before. Later, I would go on to spend most Sunday afternoons visiting their home after the church service and celebrated many holidays there too, including Thanksgiving, a holiday that we do not observe in Scotland.

I would attend the Mount Pleasant church for eight more months, building friendships and attending lunch with various families within the community before being asked by my new friend Ruby Weaver whether I ever had wished for a dress. Shortly after, we discovered we had been born only days apart, and so as a birthday gift she sewed me a Mennonite dress, which I am shown wearing

on pages 111 and 112. The style is known as a "cape dress," in reference to the "cape," which is an additional layer of fabric attached at the neckline that covers the bust down to the waist, where it is sewn into the elastic casing. Functionally, it is an additional layer of modesty to cover a woman's figure and visually separates the wearer from worldly fashions.

This act of acceptance by the community was distinctly touching, given that I had never owned a handmade dress before. In exchange for my dress, I made Ruby a family portrait, showing Ruby, her husband, Titus, and their then-seven-month-old daughter, Erica, shown on page 27. The use of a mechanically reproducible craft (the photograph) in exchange for a unique, one-off item can be seen as symbolic of our relationship and the corresponding worlds to which we belong.

My weekly church attendance has not come without mixed reactions. My parents have taken a keen interest in my newfound relationships, and many friends and close colleagues have made comments and asked questions. "Are you a Mennonite now?" is often asked in a strange tone, particularly after one hears I was gifted a dress. One person went so far as to exclaim that we could no longer be friends should I become a member of the Mennonite church—which would be in stark contrast to the Mennonites' acceptance of those different from themselves. As the Bible encourages, Mennonites practice Christian kindness to their neighbors, whom they regularly interact with, visit, and gift homemade foodstuffs. Those who have strayed from the community or have perhaps become lost on their journey as Christians are regularly prayed for at home and in prayer meetings held at the church. Many of my other friends found the stories and photos of my interactions fascinating, and viewers often asked me about how I became involved and about my friendships. They have even asked me to take them to church.

As my relationships within the community grew, I was consistently struck by the misunderstandings that the majority of society holds about plain people, including the beliefs that they are exempt from paying taxes, live "off the grid" (a term I have deliberately chosen here for its myriad mixed meanings and connotations), and do not register the births of their children. None of these assumptions are true. Still, plain people consider themselves to be in the world but not of the world. As stated in Romans 12:2, "And be not conformed to this world: but be ye transformed by the renewing of your mind, that ye may prove what is that good, and acceptable, and perfect, will of God."[2] The world is considered a place to pass through, and while their salvation and subsequent entrance into heaven is not guaranteed, their strict adherence to biblical teachings, kindness, and unconditional acceptance of those who want to do right in the eyes of the Lord are something to be marveled at. They live a Bible-taught way of life, evidenced in every area: speech, dress, business, social purity, recreation, education, and nonparticipation in politics and warfare. They are strongly opposed to war and are now given religious exemption from the United States' military draft. They believe in the separation of church and state, nonconformity to the world, discipleship, and being born again by practicing adult baptism.[3]

Some Mennonites refer to themselves as "the quiet in the land,"[4] a phrase I came across multiple times in the copious amounts of reading I did before approaching the church in Mount Pleasant. *Quiet* should not be taken literally, for their homes are often quite noisy—numerous children, friends, and neighbors often gather for meals—but the noise comes from the occupants rather than from gadgets such as televisions and radios. They believe that the television and radio spread evil messages and can therefore corrupt Christian beliefs. As such, children are

found playing together, building things, or reading books. A favorite game is to play church! Those who are not old enough to read or cannot read well are always begging to have a story read to them. Storytelling is used for entertainment purposes as well as for reinforcing biblical principles and practices, and there are many conservative Christian publishers that publish books especially for conservative Anabaptists, both adults and children. These books often show characters in plain dress and in a rural setting, the sort of areas in which many plain communities live.

This quieter home experience, away from all the gadgets and modern "smart" devices, stands in stark contrast to the lives of many families today who often use "screen time" as a child minder, in an attempt to save two already overburdened parents from having to entertain the children after both have spent the day at nine-to-five jobs. This all-too-real modern parental practice calls us to consider whether our current lifestyle is actually desirable or practical for our families. I had to ask myself, would our marriages last longer, our children be emotionally and physically healthier, and our lives be less materially focused if one parent were able to stay home?

My journey in meeting, fellowshipping, and developing friendships with members of such a conservative Christian community has afforded me many opportunities to assess my current way of life and my kindness and thoughtfulness toward others. Children are taught the acronym JOY, which stands for Jesus, Others, Yourself and is the order of priority of consideration. In contrast to these teachings, at the time I heard my first sermon in Mount Pleasant, I was single, without any dependents, and living with no family in the same country. I essentially had free rein over what I did with my time, money, and efforts. However, it was at a service about contentment that changed this situation for me. I distinctly remember being deeply touched by the idea of sacrifice and how making small sacrifices would benefit others. After all, would we *really* miss that twenty-dollar bill sitting in our wallets? Or would it be more beneficial to donate it to another cause? I couldn't honestly even tell you what sum of money is in my wallet right now, which leads me to believe that I wouldn't miss it should it one day vanish.

All images taken for this project were made on black-and-white film, which was hand-processed, hand-printed, and toned in selenium. Such a choice is reflective of the Mennonite lifestyle in two ways. First, such plain groups are well-known for their crafts. Woodworking, quilting, and farming activities are among their best-known business ventures. These hands-on labors comport with Psalm 90:17, which speaks of the importance of working with one's hands: "And let the beauty of the Lord our God be upon us: and establish thou the work of our hands upon us; yea, the work of our hands establish thou it."

Processing the photographs by digital technology would be handing control over to computer-operated machines, which seemed to be completely mistuned to Mennonite life; the choice to hand-process and hand-print all of the photographs was more in keeping with Mennonite labors. Mennonites have a practical approach to new technologies, asking, "Do these newer technologies adhere to our lives as practicing Christians?" and "Do these modern technologies offer us temptation into sin?" For example, they use the Internet only for business and sometimes for contacting other community members. Generally, though, letters and cards are handwritten and sent by mail to friends and family. The handcrafting of the photographs is reflective of a society that appreciates and admires the handmade over a digital artifact.

Varying film formats were chosen for their utilitarian aspects as well as visual qualities, such as aspect ratio;

the ratio of height to width, for example, differs between large format (4 x 5 inches), medium format (120 film), and 35mm shots. The panoramic photographs, one of which is shown on page 17, offer the viewer a wider view of a subject, one that could not be contained within a standard 35mm frame, which measures 24mm x 36mm. Taken on an X-Pan Hasselblad camera, the frames are the same height but twice as wide as a standard 35mm frame.

 Traditionally, view cameras were used to shoot architecture, due to their abilities to adjust perspective issues that arise when pointing a camera toward a tall building. The sheet film is loaded into individual film holders, which have to be switched out between each shot. This process produces extremely detailed photographs that can be greatly enlarged but does not lend itself to continuously moving subjects; hence I chose to use the view camera for landscape and building documentation. Roll film (35mm and medium format) is smaller in size, and thus the cameras used are also much smaller and therefore more portable. I selected medium format film to make the portraits: it offers a huge amount of detail when shooting portraiture while also being a practical choice for shooting many sequential frames. I used 35mm film for all the candid shots; cameras and lenses are smaller and portable, and photographs can be shot in quick succession with the light meter built into the SLR camera.

JANUARY 2023

Acknowledgments

First, I would like to extend my sincerest thanks to all members and regular attendees of Mount Pleasant Mennonite Church. Their kindness, biblical teachings, and unconditional acceptance of my presence within their community has had a profound influence on my life. In particular I would like to thank Glen, Wanda, and Howard Weaver for their continued friendship and for hosting me during my visits to the area after moving to Chicagoland. I also thank Josh and Miriam Martin for their hospitality throughout my time in southern Illinois as well as after my move north. The Bible studies that Miriam and I have shared have had a distinct impression on my life.

Additionally, at Southern Illinois University Carbondale I am grateful for Dan Overturf, Alison Smith, and Jyotsna Kapur. Their input and influence on what was the beginning stages of this project undoubtedly shaped many aspects of this book's outcome.

My thanks go to Jay Needham of the Global Media Research Center at SIUC for generously providing funding for the book as well as for introducing Liz Wells to me.

A very special thank you is due my acquisitions editor, Jennifer Egan, for her influence, assistance, and guidance throughout the completion of this publication.

I also owe a very warmhearted thank you to the following people for their contributions and assistance

throughout various stages of the project: J. P. Rhea, Doron Alter, Lauren Stoelzle, Cade Bursell, Sarah Lewison, Kristine Priddy, Ruby Weaver, Gerald and Rosene Martin, Clair and Rhoda Weaver, Jane Walmsley, and Brian Flynn.

Finally, loving thanks go to Veronica Smolkovich, who watched my son—her grandson—Lenny every week as I worked on this manuscript, and to Stephen Frederick, my husband, for his unwavering support as I finalized this project.

Mennonites OF SOUTHERN ILLINOIS

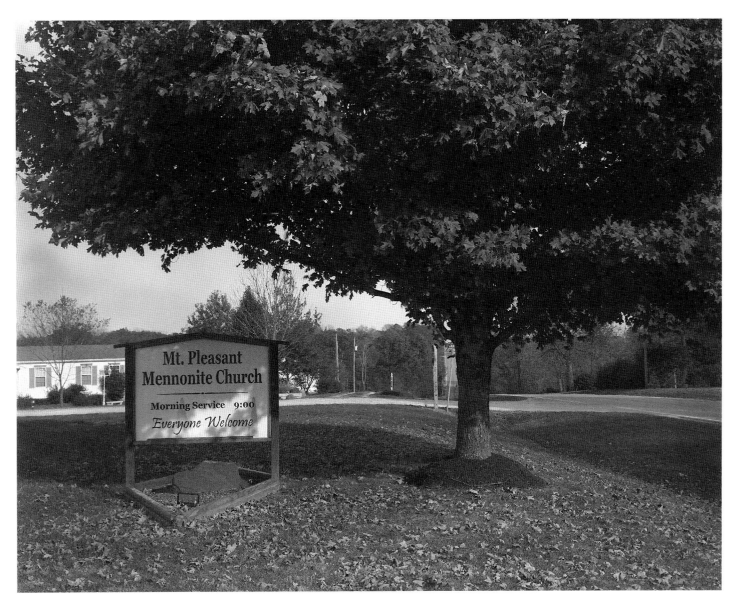

Signage at Mount Pleasant Mennonite Church, located on Route 146, just outside of Anna, Illinois, invites guests to Sunday church service. Everyone, including members of the public and individuals from other Mennonite churches, are warmly welcomed with genuine Christian kindness. The services last two hours, with worship including a cappella singing, Bible study class for children and adults, and a morning message delivered by the ministry. *2015.*

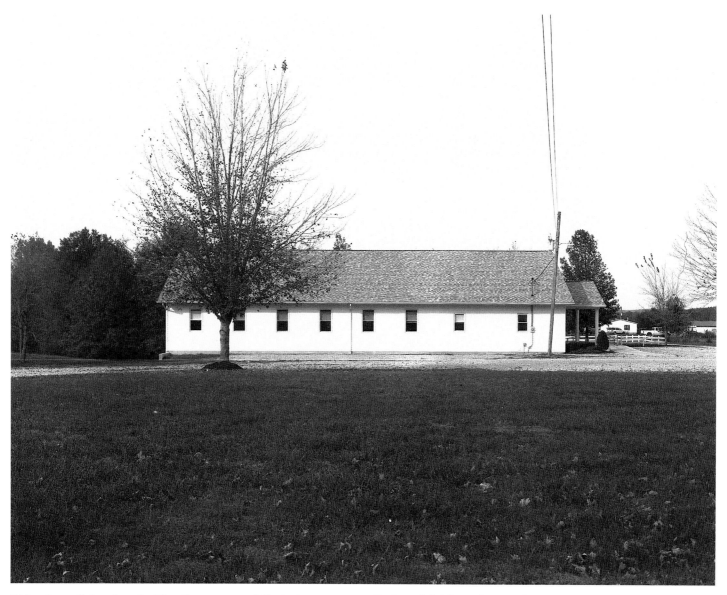

Side view of the church. The *Statement of Christian Doctrine and Rules and Discipline of the Eastern Pennsylvania Mennonite Church and Related Areas* reads, "We believe that the Church is the body of Christ, composed of all those who through repentance toward God, and faith in the Lord Jesus Christ, have been born again and were baptized by one spirit into one body, and that it is her divinely appointed mission to preach the Gospel to every creature, teaching obedience to all His commandments."[1] *2015.*

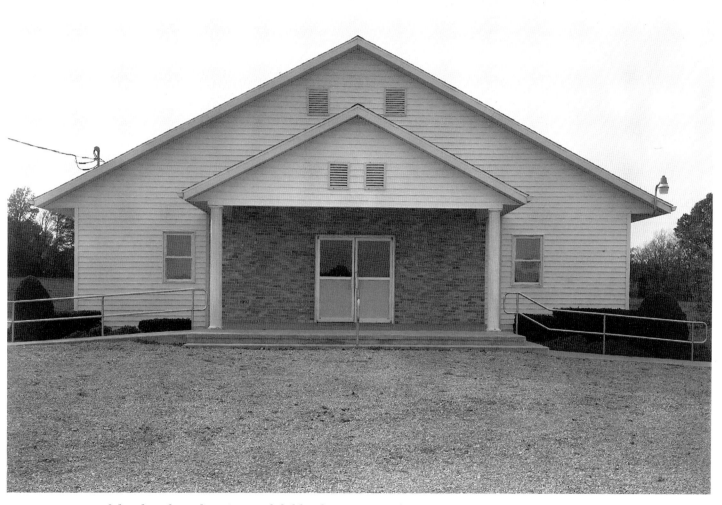

Front entrance of the church. In keeping with biblical modesty, the church's structure is simple and unadorned, without any iconography. *2015.*

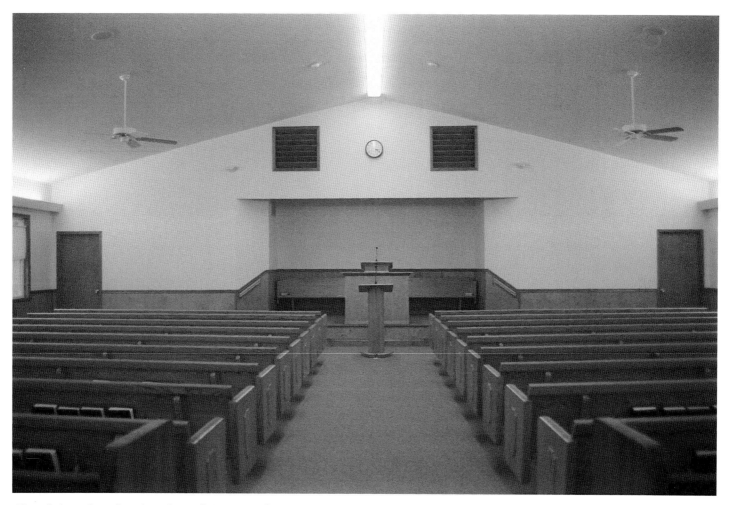

Church interior, showing the pulpit. According to the *Statement of Christian Doctrine and Rules and Discipline*, "Due to the contribution that mixed seating makes to the moral breakdown, we will follow the practice of segregated seating for worship services. Weddings and funerals may be considered exceptions."[2] Photographs are not permitted of church services, including weddings, baptisms, ordinations, and funerals; hence the church is shown here empty. *2020.*

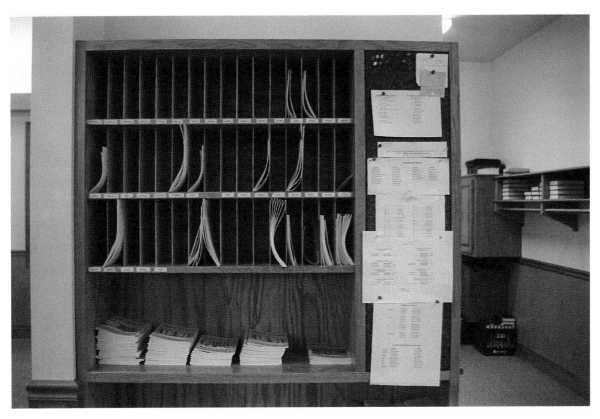

Above: Weekly papers consisting of Christian reading material and newsletters are deposited in families' mailboxes. The papers are issued by conservative Christian publishers and are written from a biblical perspective. Included is literature for all family members: women (wives and homemakers as well as single women), men (husbands and heads of the home as well as single men), teenagers, youth, and children. Mainstream media outlets, such as newspapers, are avoided for their secularism and worldliness.[3] *2020.*

Left: For families, mailboxes are labeled with the husband's name, as he is considered the leader within the home. In conversation, families are often referred to by the husband's name; for example, "Duane's" would refer to Duane Weaver and his family. *2020.*

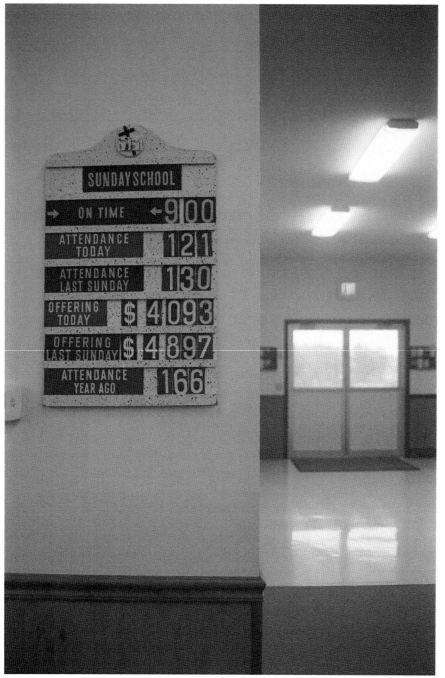

Weekly collections are made for various funds within the church and for other Christian organizations, such as publishing companies. A basket is passed around the congregation while a song is sung; individuals deposit monies contained within envelopes into the basket. Children will often put small change into it.

Commercially available insurance policies are avoided in adherence to 1 Corinthians 12:26; 2 Corinthians 12:14; and Galatians 6:2.[4] Instead, the church periodically collects for the Brotherhood Assistance, which is used to cover expenses such as medical bills or expenses associated with any automobile accidents, for instance. The reporting to church members of monies collected aligns with the Mennonites' biblical sense of honesty, avoiding any secrecy over financial matters within the church. *2020.*

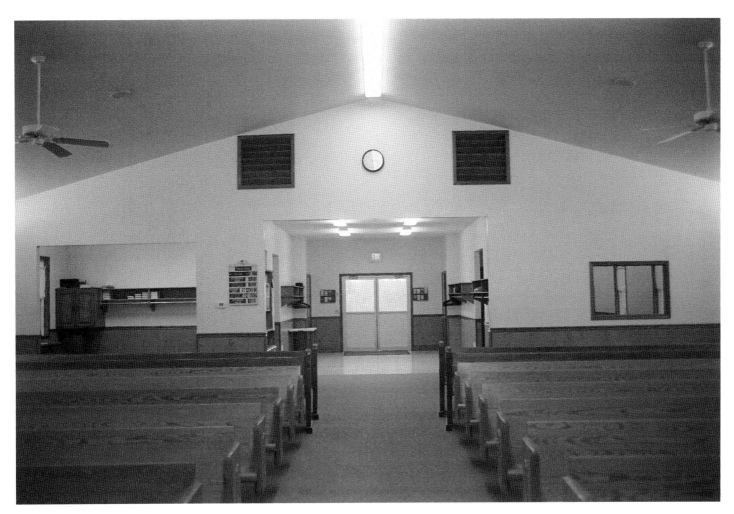

The view from the pulpit, looking toward the vestibule. Before individuals can join the church, they must go through instruction, which is taught by the ministry and covers all the rules, regulations, and expectations of church members, all of which can be found in the *Statement of Christian Doctrine and Rules and Discipleship*, which takes the form of a small booklet. *2020.*

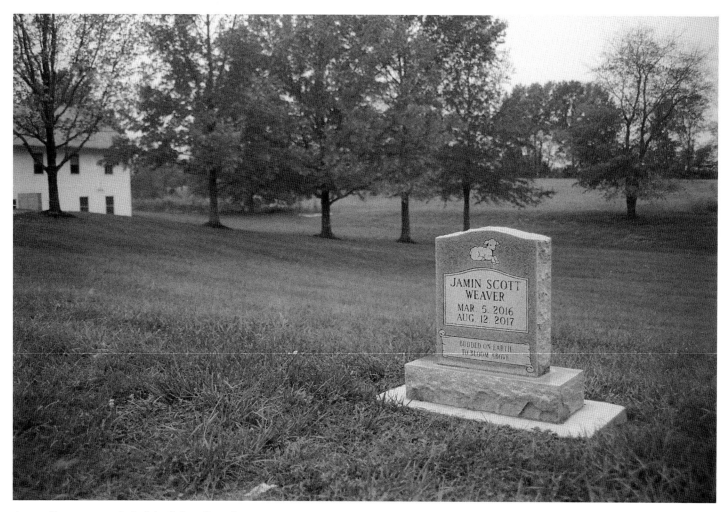

A small cemetery is behind the church. Jamin Weaver passed away, age seventeen months, due to a rare genetic condition. Mennonites believe that a soul is created at the moment of conception and that all individuals, regardless of their abilities in life, are a blessing to their parents and the church. Gospel simplicity characterizes funeral services and cemeteries, where no flowers are present.[5] *2020.*

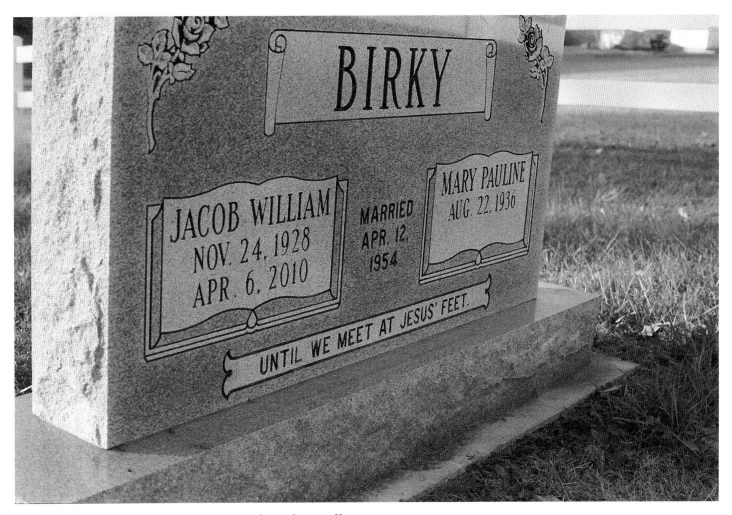

Wanda Weaver's parents' headstone stands in the small cemetery on the church grounds. Since photographing, her mother has also passed away and has been buried next to her father, Jacob. The Mennonites consider themselves to be in but not of the world; they are merely passing through this world on their way to an eternal life. Ultimately, they believe they will face judgment by God. Out of respect for the deceased, all graves are dug by hand by male church members. *2015*.

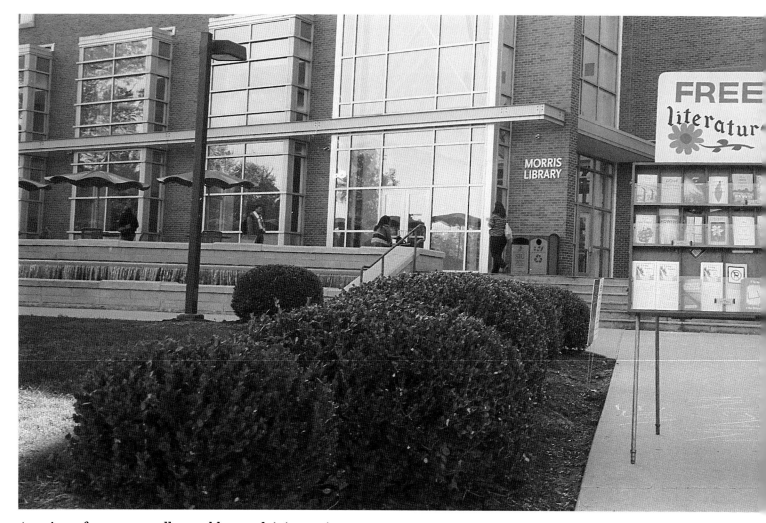

A variety of tracts— small pamphlets explaining various aspects of Christian living—are offered to students at Southern Illinois University Carbondale during a street meeting, held twice annually at the college. Evangelizing is considered an important practice to share God's word. In addition to street meetings, Mennonites sing in care homes surrounding their community, disperse Christian-based literature within the community, and hold church services several times a year at a local prison. *2016.*

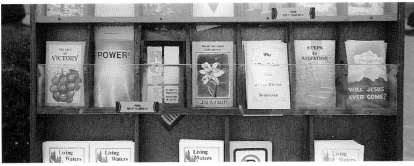

Tracts are offered free to the public in street meetings, at businesses, and at church. *2016*.

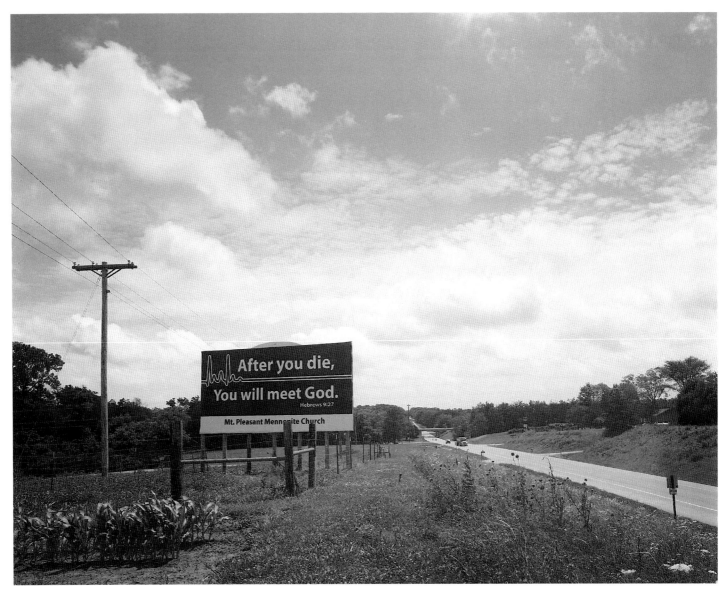

Driving west on Route 146, passersby are reminded of the Mennonites' belief that everyone will face judgment before God. Public messages such as this sign are part of the Mennonites' evangelizing efforts. Other signage is commonly displayed above their roadside mailboxes, as seen on page 91. *2015.*

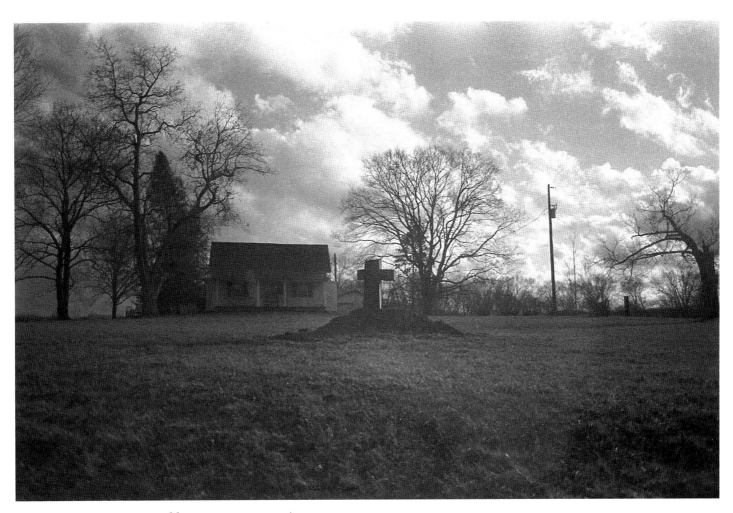

A cross, carved from wood by Titus Weaver using a chainsaw, stands in Titus and Ruby's front yard as a public declaration of their faith. *2020*.

And if it seem evil unto you to serve the Lord, choose you this day whom ye will serve; whether the gods which your fathers served that were on the other side of the flood, or the gods of the Amorites, in whose land ye dwell: but as for me and my house, we will serve the Lord.

Joshua 24:15

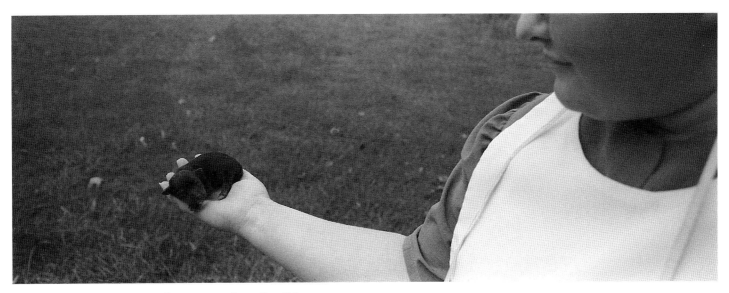

Frieda Troyer, who specializes in toy breeds of dogs, holds out a two-day-old Chihuahua to be photographed. She describes her dog breeding as her "project," which supplements her family's income. Since photographing, Frieda and her family have moved their membership from the church in Carrier Mills to Mount Pleasant in Anna. *2014.*

Automobiles, considered gifts from God, are in keeping with the Mennonite practices of biblical modesty and separation: they are dark in color and do not have expensive or sports features.[6] *2014.*

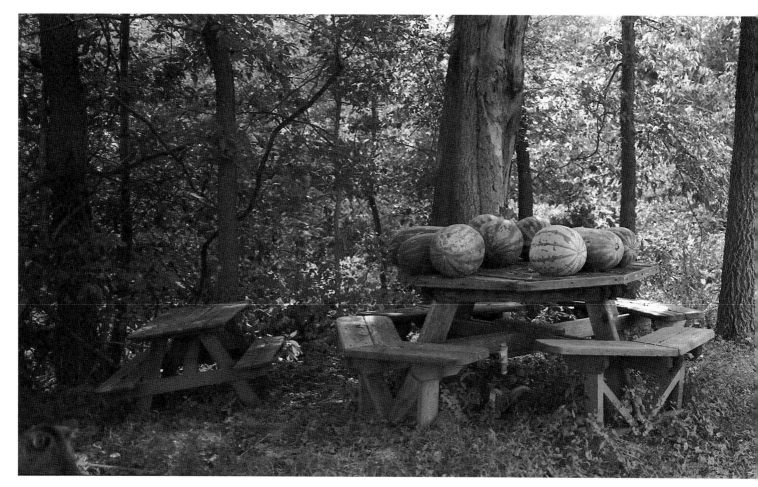

During the spring and summer months most women within the community will have large gardens, where they grow a wide variety of fruits and vegetables, many of which are canned to be used throughout the winter months. *2014.*

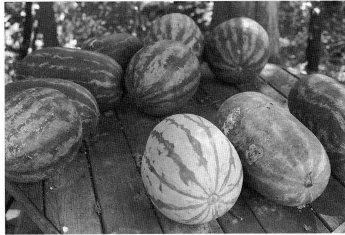

Homegrown watermelons. *2014.*

Above: Cats are kept to control the mice and rat populations in the barns. Generally they live outside, rather than be treated as pets inside the home. Children enjoy playing with and caring for them, in addition to many other animals, including dogs and chickens. *2019*.

Right: Josh and Miriam Martin, newlyweds, sit in their home for a photograph. They married in New York State in 2015 and then moved to Illinois. Miriam and I have formed a strong friendship, based primarily upon our weekly Bible study sessions and our sharing of meals in their home. At the time of photographing, Josh worked for David Weaver, another church member, who runs a building company. In March 2021, Josh and Miriam and their three children moved to Pennsylvania to be closer to both their families. *2016*.

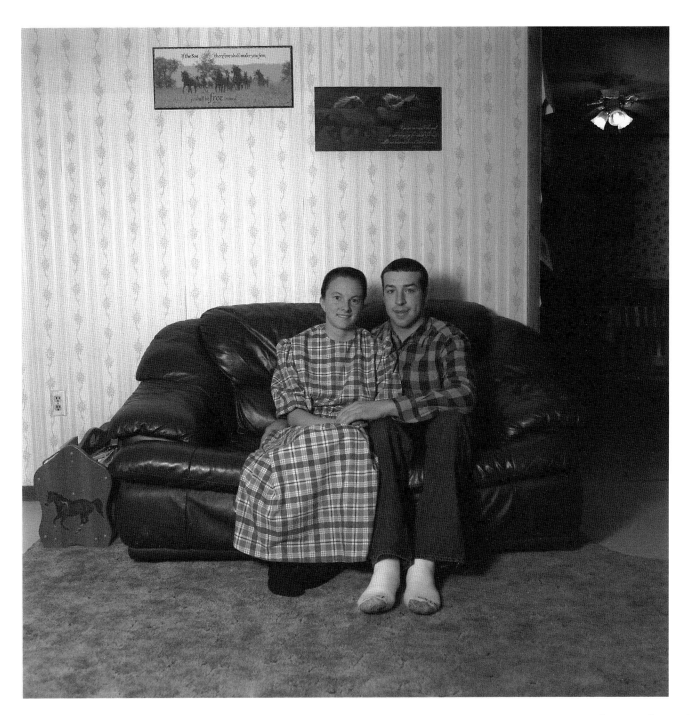

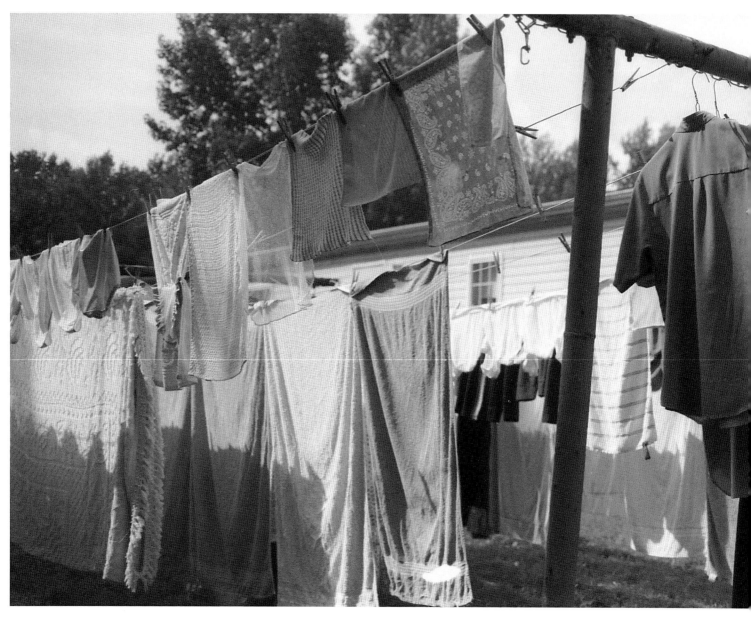

Laundry, including cape dresses, worn by all women of the church, hangs to dry. Black hosiery is also worn in all areas of public life and must be of at least 30 denier (appropriately thick and opaque). Men wear dark slacks and button-down shirts. A necktie is considered unnecessary.[7] *2014.*

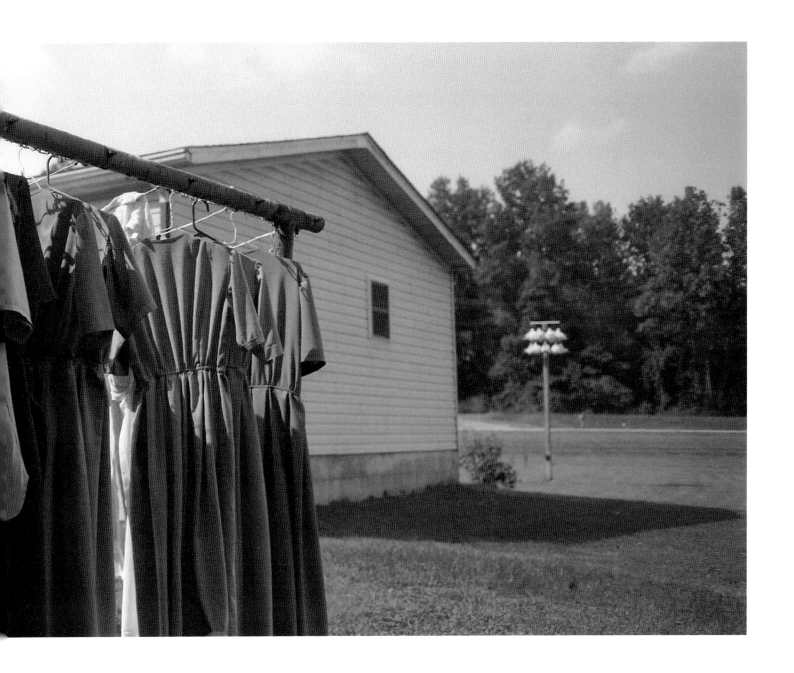

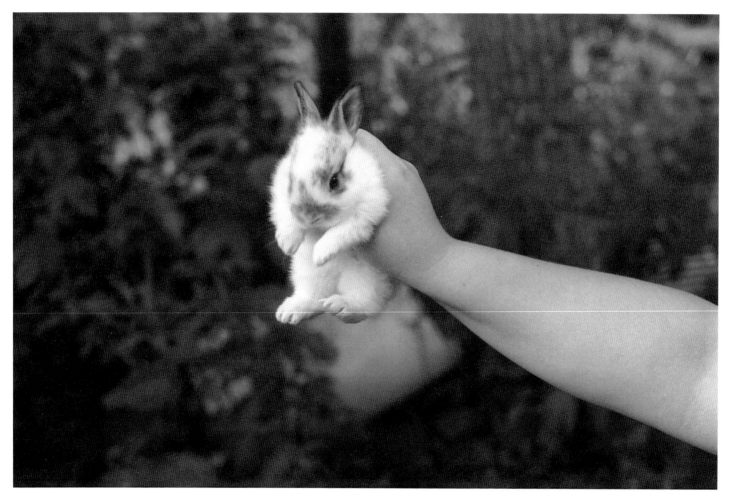

Above: Rabbits are bred for their meat and fur. The rabbit shown is owned by Frieda Troyer's brother, another example of youngsters owning and caring for animals in and around the home. *2014.*

Right: Titus, Ruby, and baby Erica Weaver pose in front of their home. Ruby sewed and gifted me my first cape dress in exchange for this photograph. At the time of photographing, Titus was co-owner of Triple C Meats, a butcher shop (shown on pages 77 and 78). *2015.*

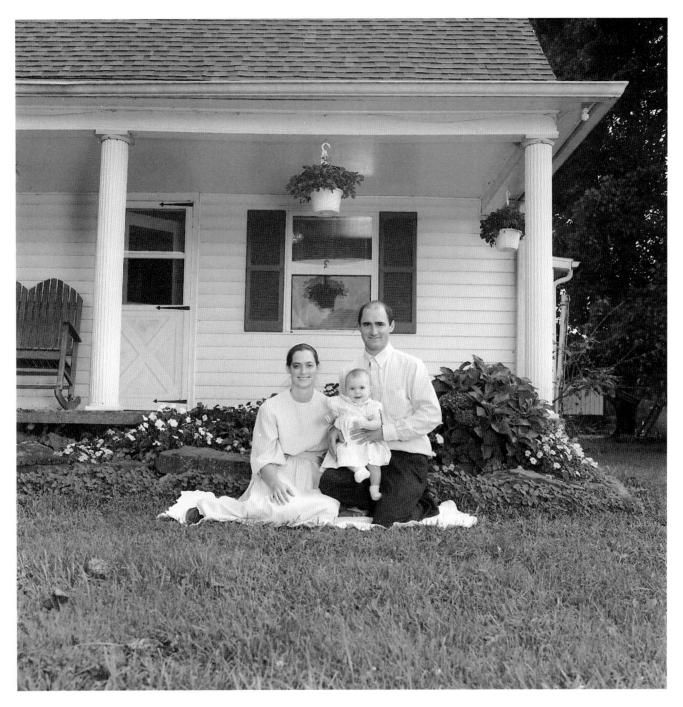

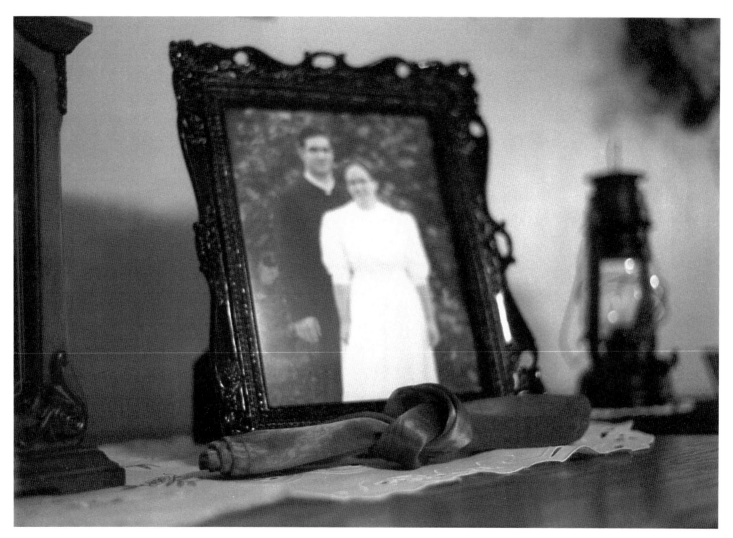

Above: A tied knot, a symbol of the intertwining of two individual lives into one, in accordance with Mark 10:8—"And they twain shall be one flesh: so then they are no more twain, but one flesh"—is displayed in the home. As photographs are not permitted in the church during wedding services, couples will usually have their picture taken after the ceremony or after they have returned from their "wedding trip," which is what many people would refer to as a honeymoon. Wedding trips last two weeks and are usually taken within the United States. 2015.

Right: Large families are cherished. Here, Duane and Miriam Weaver are shown with their six children in Giant City State Park. 2015.

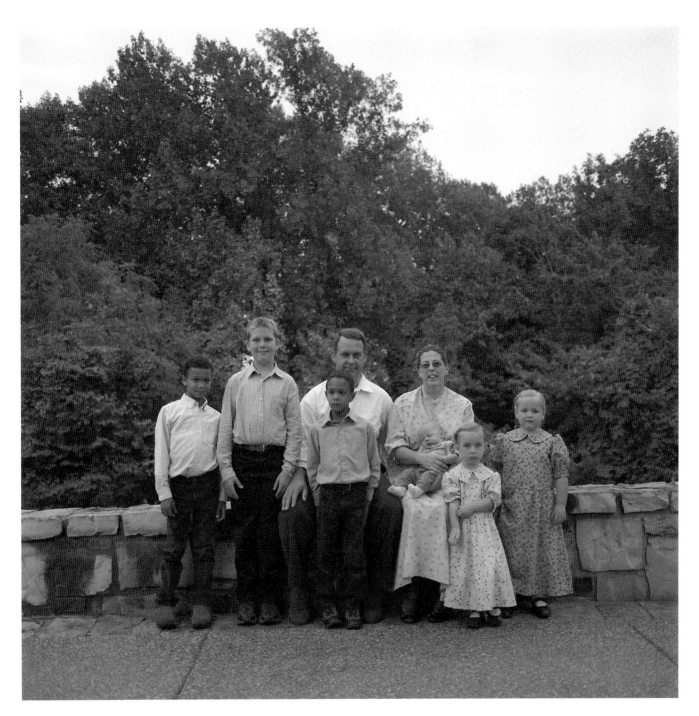

Above: The Mennonites consider the worship of idols a sin; hence, Bible verses are favored over icons as expressions of faith within the home. *2015*.

Right: The Gehman family, including their dog, Shadow. Joseph Gehman runs Martin's Sharp-All Shop, in Anna, Illinois, which sells and services lawn mowers and mowing equipment. *2015*.

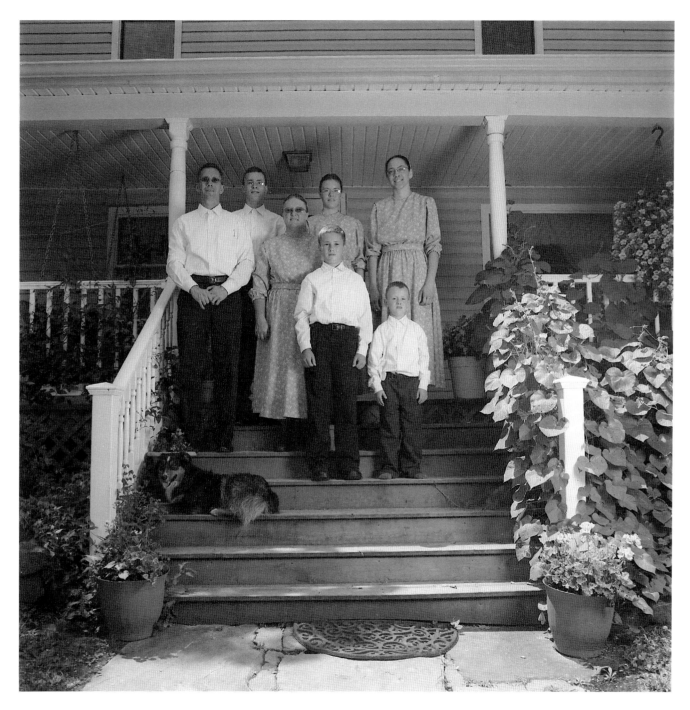

Wanda Weaver pieces her quilt tops by machine and then hand quilts them in her wooden frame at her home. Quilts are used within the home, are gifted to friends and family members, and are often given to visiting ministry and medical professionals as a token of appreciation for their services. The patterns used tend to be more traditional. My husband and I received a quilt from Glen and Wanda as a wedding gift when we married in 2017. *2015.*

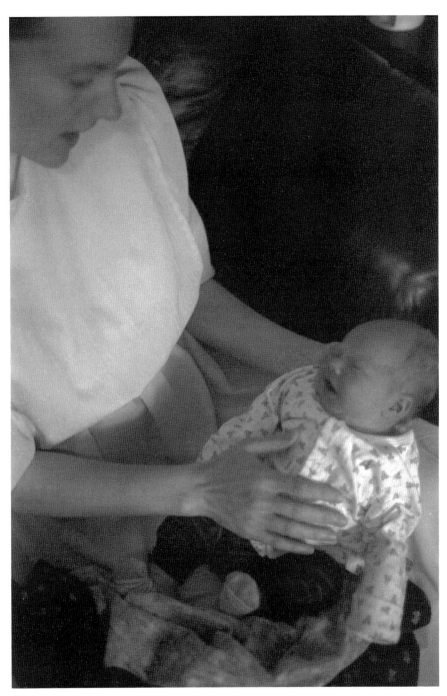

Miriam Martin (shown on page 39) soothes baby Alex, her first child, born April 2017. Women within the community of Mount Pleasant attend regular prenatal appointments with their doctors and almost always give birth in the hospital. A flat fee is charged to families for having their children in the hospital, as church members do not purchase health insurance. After the birth, a single lady (usually a family member) will act as "baby maid" and come for several weeks to take care of the new mother and baby. She will cook, clean, and run the household to allow the new mother to rest and bond with her infant. Women from within the church will bring meals to the family for several weeks, or perhaps even several months in instances of large families or twins. *2017.*

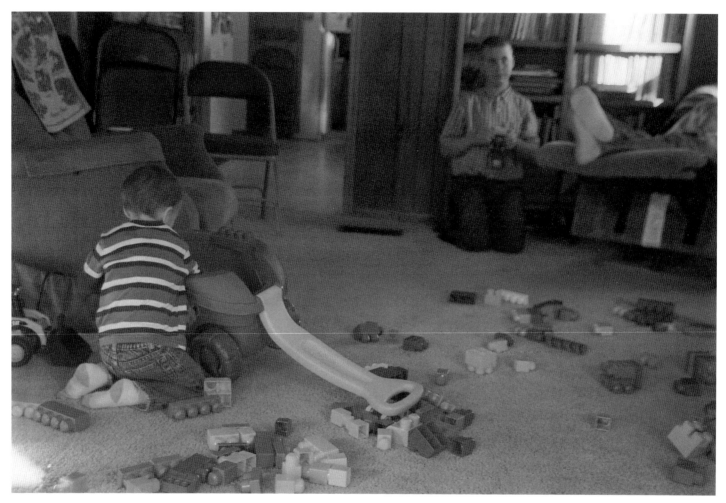

Glen and Wanda Weaver's grandchildren visit after church on a Sunday afternoon. After the service, a host family will have visitors and perhaps some families from within the congregation for lunch. The visitors and hosts will gather to socialize for a few hours after eating. Guests may be from sister churches, the surrounding non-Mennonite communities, out of state, or even out of the country. If traveling, families will usually "gas up" and prepare on Saturday, so as to avoid any unnecessary business transactions on Sunday. One vehicle may even be chosen for travel over another if it is more fuel efficient or has a larger fuel tank, in order to avoid making a purchase of gas on Sunday, which is considered the Lord's day. *2016.*

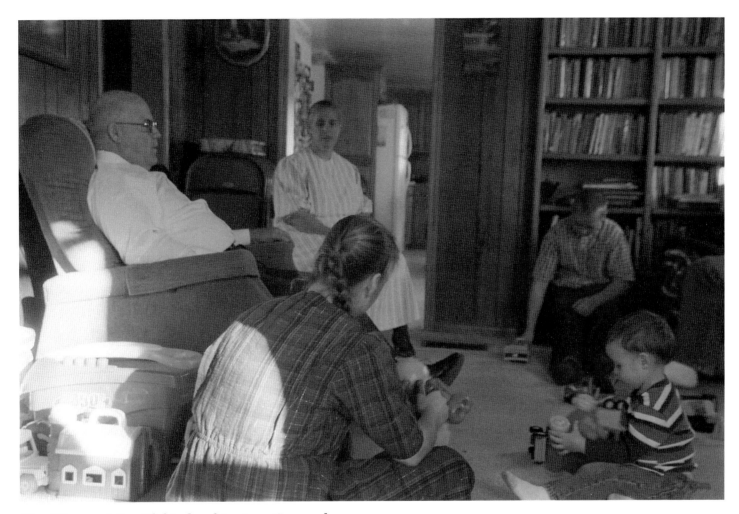

Glen Weaver visits with his daughter Lucy Cross, who is a member of a neighboring sister church, and three of his grandchildren on a Sunday afternoon. The Lord's day is well observed and is set aside as a day of devotion and worship. Overindulgence and pleasure-seeking are strictly avoided, while labor and business are avoided as much as possible. *2016*.

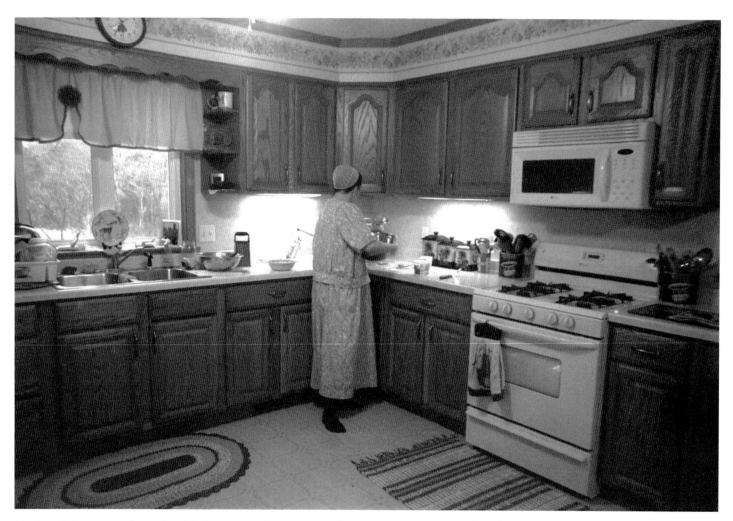

Miriam Martin works in her kitchen, wearing a maternity dress. The women hand-sew all of their dresses at home on their sewing machines, from fabric purchased at Mennonite-owned fabric stores such as Rose Cottage (shown on pages 71 through 74 and pages 106 and 107). Most women will exchange patterns, which are usually traced onto newspaper, among themselves. Miriam obtained her maternity dress pattern from one of her sisters, and the dress I was gifted was sewn from the same pattern as Ruby Weaver's dress. *2017.*

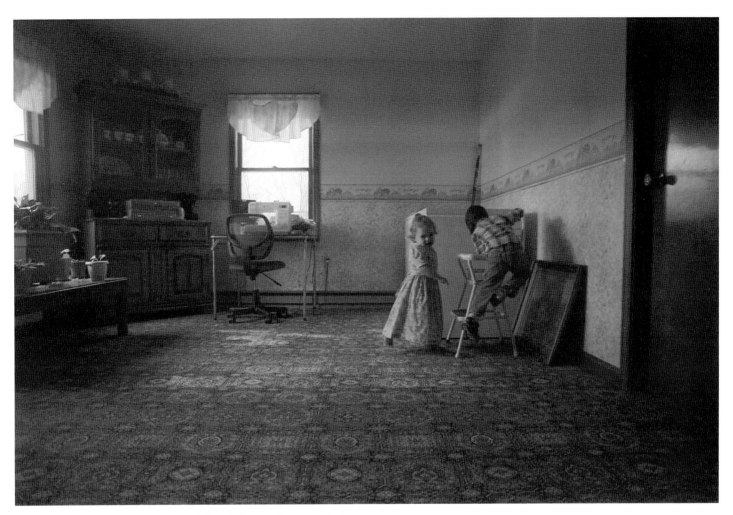

Children play on a step stool while their mothers work in the kitchen. As homemakers, women will often visit each other to help with tasks, providing ample opportunity for children to play together. Despite not starting school until first grade, the children are well socialized. When a father's occupation permits, his young boys may ride along with him for the workday. *2016*.

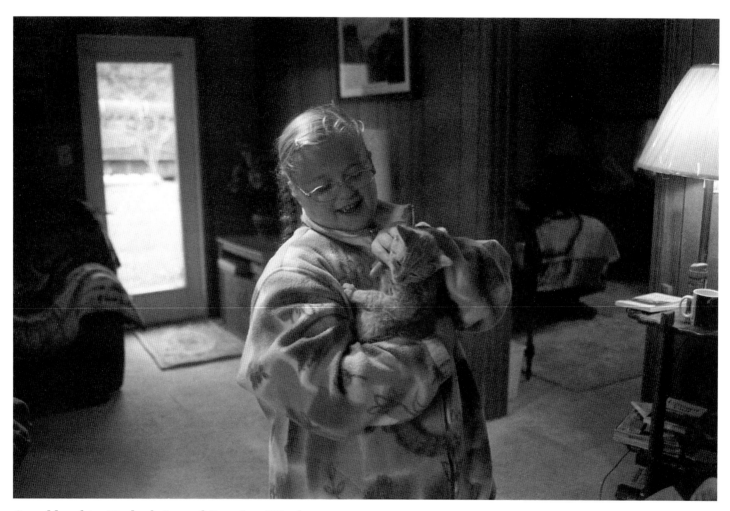

Granddaughter Kaylee brings a kitten into Wanda Weaver's living room to be photographed. She is a lover of animals and cares for the family chickens and cats. *2020.*

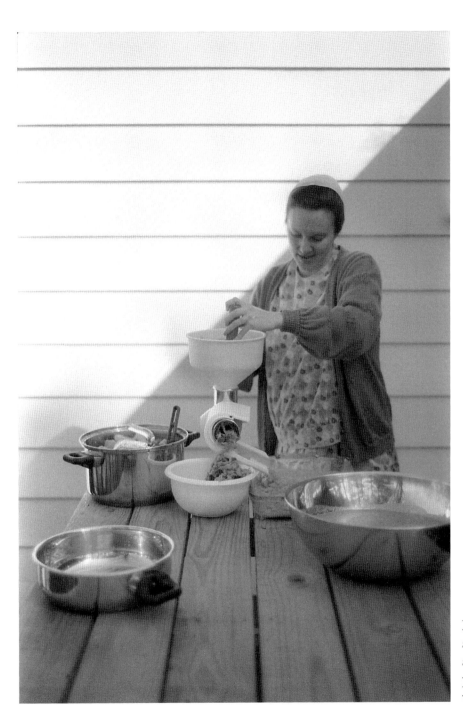

Miriam Martin works at making applesauce on her patio, ahead of the arrival of her first baby, Alex (shown on page 33). After processing the apples, the sauce is canned. *2017.*

Glen and Wanda Weaver sit for a photograph. Like all male church members, Glen wears a coat without a lapel collar, which is considered unnecessary and not in accordance with plain dress. After purchasing a suit from a retailer, the men will send their suit jackets to a seamstress to have the regular collar removed. The removed collar is then sewn onto the jacket in a more modest fashion, as can be seen on Glen's jacket. Wanda's dress and her covering were made by herself at home. She said the painting on the wall reminded her of British Columbia, Canada, where she lived when she met and dated Glen. They moved to Illinois after marrying in 1975. *2015.*

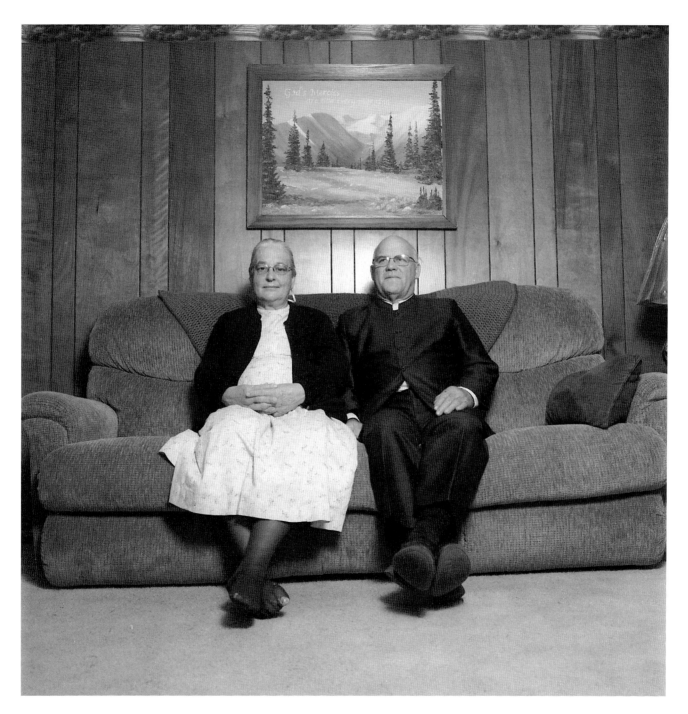

And the Lord God took the man, and put him into the garden of Eden to dress it and to keep it.

Genesis 2:15

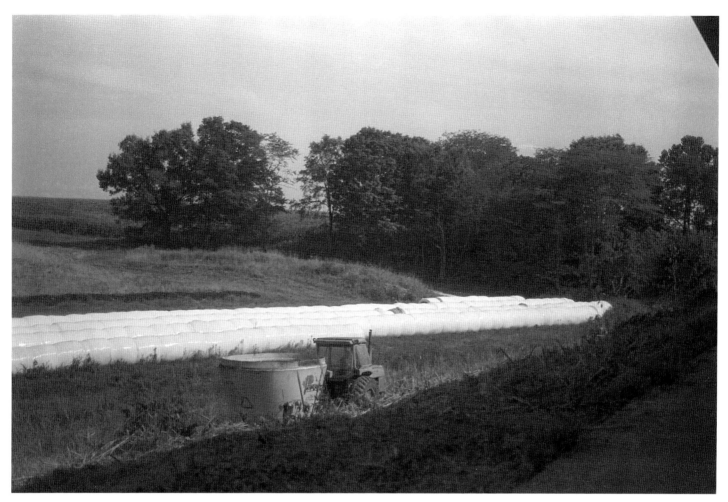

As practicing Christians, Mennonites believe in the absolute truth of the Bible, including the Genesis account of Creation—that God made the earth and all the creatures that inhabit it, including humankind. As such, living off the land and the creatures made by the Lord is practiced by many families. Additionally, farming is a family-friendly venture—the men work close to the home and return for lunch, allowing the family to eat together during the workday. Children are taught the importance of hard work from a young age and will have many responsibilities within the home, farm, or family business. In my time among the Mennonites, I always found the children to be very responsible and mature for their age.

Here, hay bales line up in Glen Weaver's field. The hay is used to feed the cattle, which are raised from calves and then sold to be fattened up for slaughter. The women will often use hay as mulch in their gardens. *2018*.

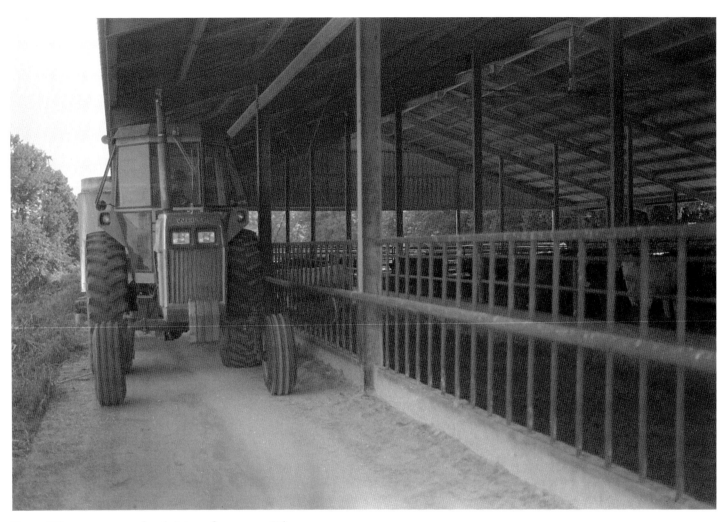

Dana Weaver, age twelve (pictured on page 29), dispatches feed to the cattle belonging to his grandparents Glen and Wanda Weaver. *2018.*

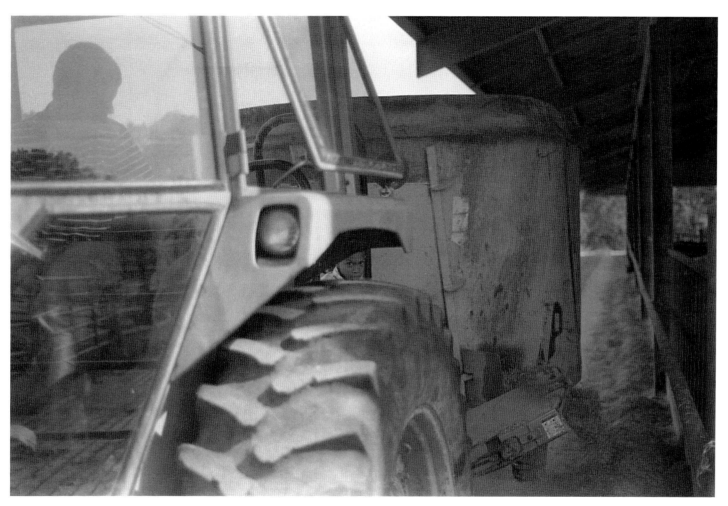

Without television or radio serving as entertainment, children are keen to help around the home, farm, or family business where appropriate. Here, Dana Weaver's brother Elijah rides along on the back of the tractor while Dana feeds the cattle. *2018.*

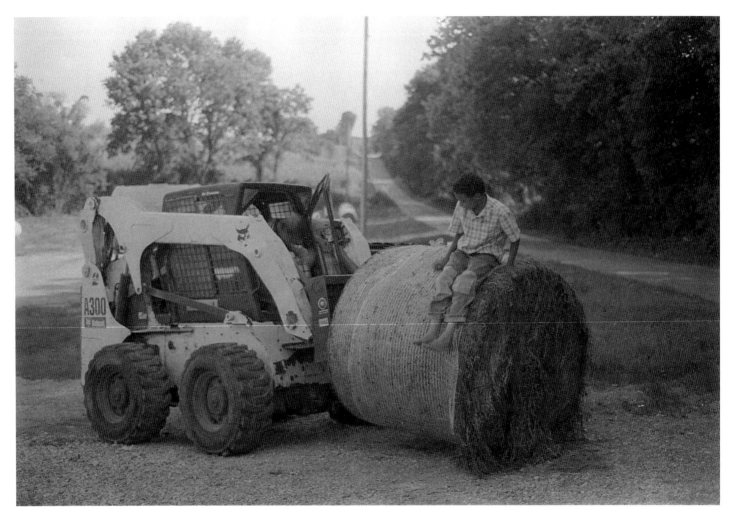

Children take ample opportunity for play, even while doing their chores. Elijah and Dana Weaver are shown here preparing some hay to supplement the cattle's feed. Living within the area surrounding the church is a priority for all families at Mount Pleasant, and Elijah and Dana's family (shown all together on page 29) live within walking distance of Glen and Wanda's home. Their father, Duane, also works on the farm, which allows him to return home for lunch and to spend time with family when working. *2018.*

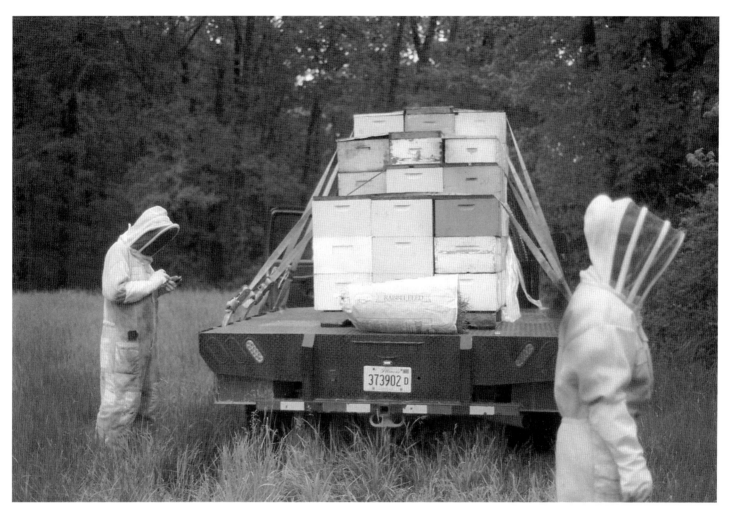

Beekeeping is another agricultural pursuit practiced within the Mount Pleasant community. Here, Ernest Weaver's children show me the hives that they keep on properties owned by other church members surrounding their community. As in many of the Mennonites' other business pursuits, family and other church members are heavily involved in tending to the bees and harvesting the honey. The honey is sold at local stores within and without the community, as well as at farmers' markets. *2017.*

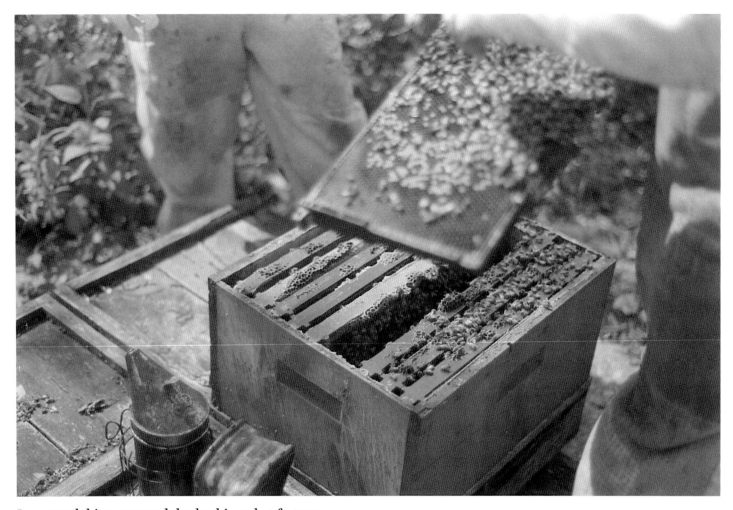

Langstroth hives are modular beehives that feature vertically hung frames, a bottom board with an entrance for the bees, boxes containing frames for the brood and honey (the lowest box for the queen to lay eggs and the boxes above where honey may be stored), and an inner cover and top cap to provide weather protection. This type of hive allows the bees to build honeycombs into frames, which can be moved with ease.[8] 2017.

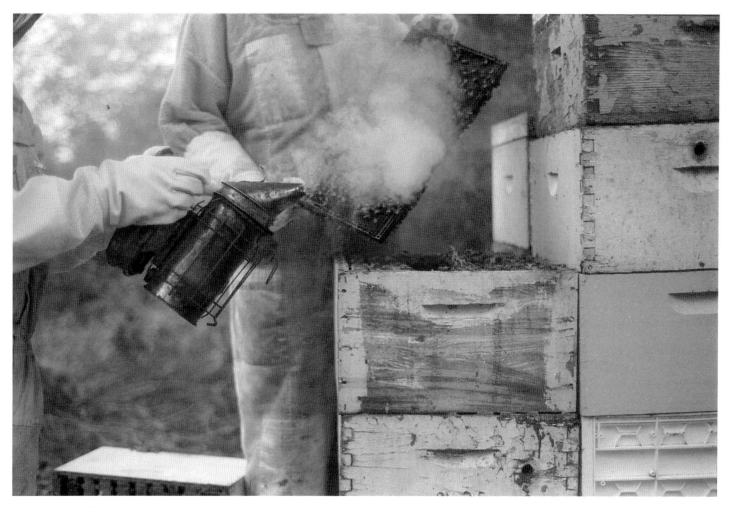

Smoke is applied to the bees to keep them calm while inspecting the hive. 2017.

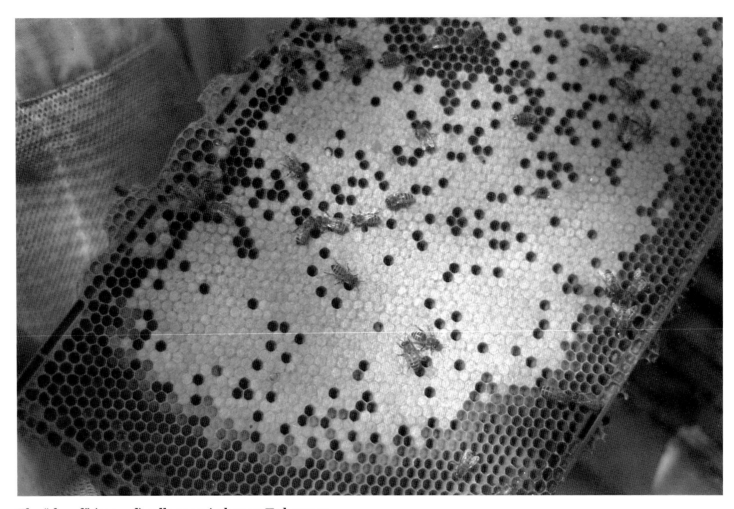

The "closed" (capped) cells contain honey. To harvest the honey, the beekeeper must uncap the cells with an instrument such as an uncapping fork or an uncapping knife. After harvesting, the honey is filtered to remove any debris such as wax. The leftover mixture can be heated up, allowing for the beeswax to be harvested. *2017.*

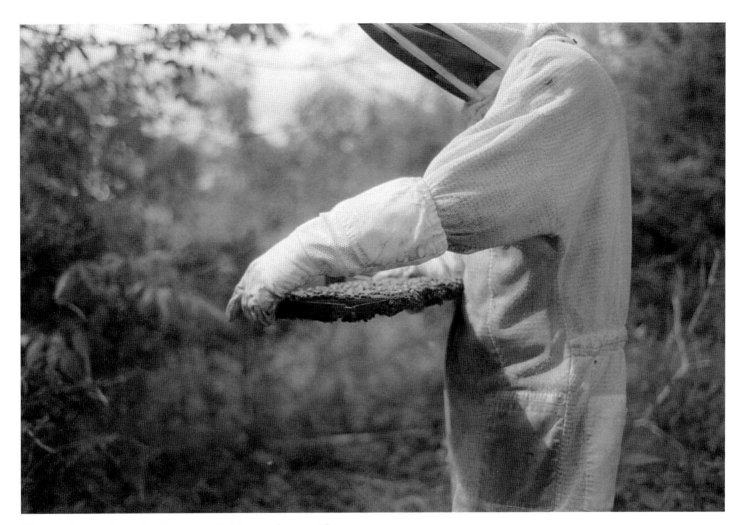

Here, a frame from the Langstroth hive is shown. The frames are spaced within the hive to prevent bees from attaching honeycombs to adjacent frames or from connecting frames to the wall of the hive. These movable frames allow the beekeeper to manage the bees in a way that, until the invention of the Langstroth hive in 1851, was formerly impossible.[9] *2017.*

And these words, which I command thee this day, shall be in thine heart: And thou shalt teach them diligently unto thy children, and shalt talk of them when thou sittest in thine house, and when thou walkest by the way, and when thou liest down, and when thou risest up.

Deuteronomy 6:6–7

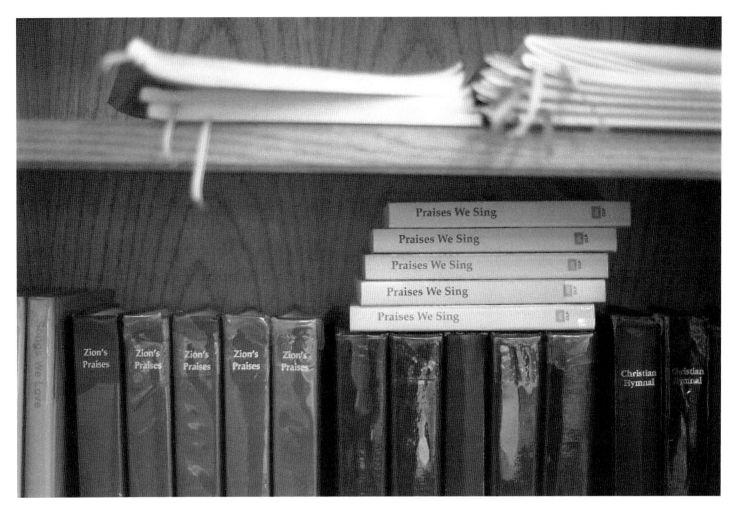

Songbooks line the shelves at the Mount Pleasant School. Singing is considered an important part of worship and is included in daily devotions and church services. Additionally, singing in small groups is engaged in for personal enjoyment and inspiration in private gatherings, in homes, and for the benefit of the sick and aged, as well as during Christian testimony in street meetings, in school settings, and in institutions such as jails, hospitals, and charitable homes. *2015.*

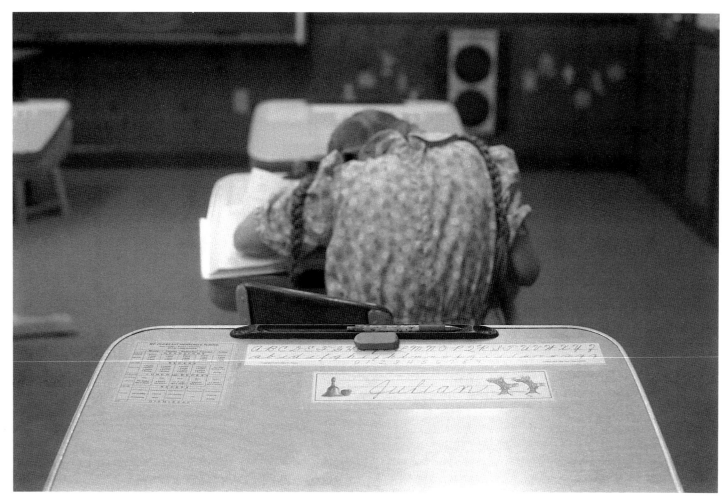

The education of children in a wholesome Christian atmosphere is considered a biblical imperative. Mennonites believe that the church should assist parents in fulfilling this responsibility by sponsoring Christian day schools with a Bible-based curriculum.[10] *2015.*

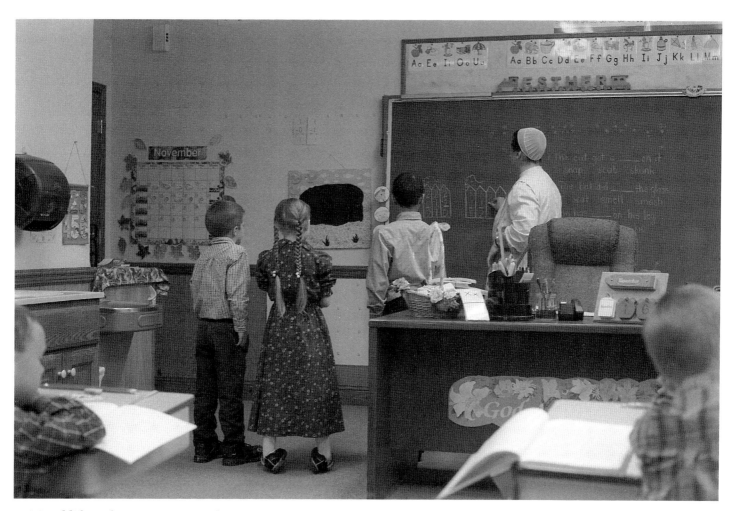

Spiritual life and consistency are the primary qualifications for all personnel of the Mount Pleasant School. The church provides periodic instruction for teachers and administrators to promote a scriptural philosophy of education and to encourage academic competence.[11] In the lower grade room, shown here, children in as many as three different grades are taught. Students are called up to the blackboard for instruction (in this instance, subtraction practice) and return to their seats to complete their assigned work. *2015.*

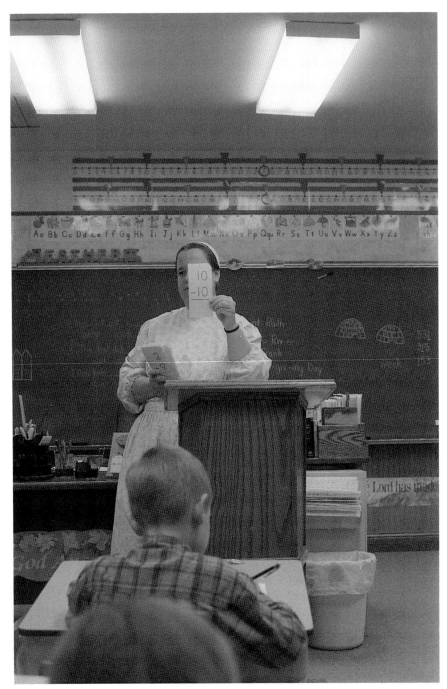

Esther Detweiler shows addition and subtraction flash cards to students in the lower grades. The Mount Pleasant School is divided into four classrooms, with an additional room for special education. Generally speaking, children are well behaved and focused on their studies. *2015*.

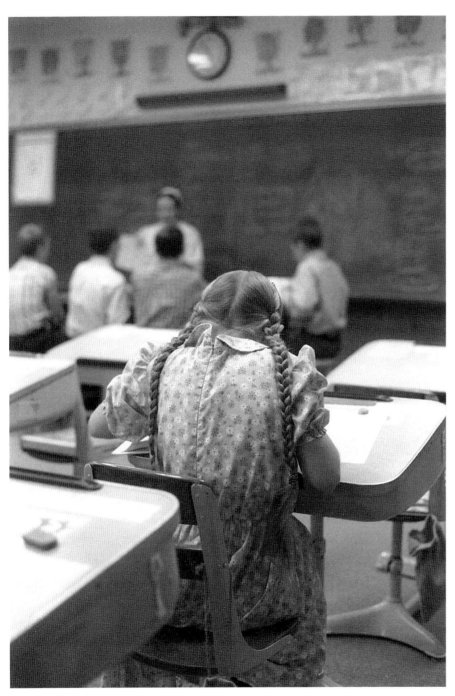

Students are assigned homework only if they do not finish the day's work at school. After school, children play, help with chores at home, or assist in family-run businesses. In addition to traditional subjects, children are periodically taken on school trips to surrounding towns and businesses. *2015.*

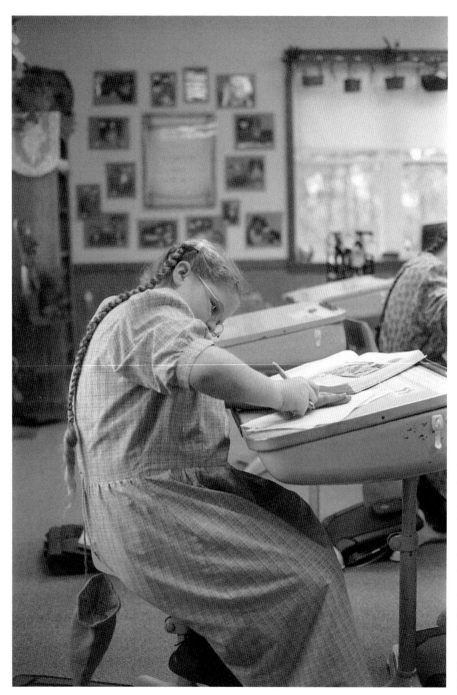

Church members and parents are welcome to visit the Mount Pleasant School and sit in the classrooms. Children are pleased to see visitors! A student is chosen to present visitors with the guest book, where they are encouraged to share their thoughts on the visit, the teaching, and the children. Within the guest book, the students each have a page where they provide information about themselves, including what they want to be when they grow up. Most children aspire to work within family businesses and raise their own family. *2015.*

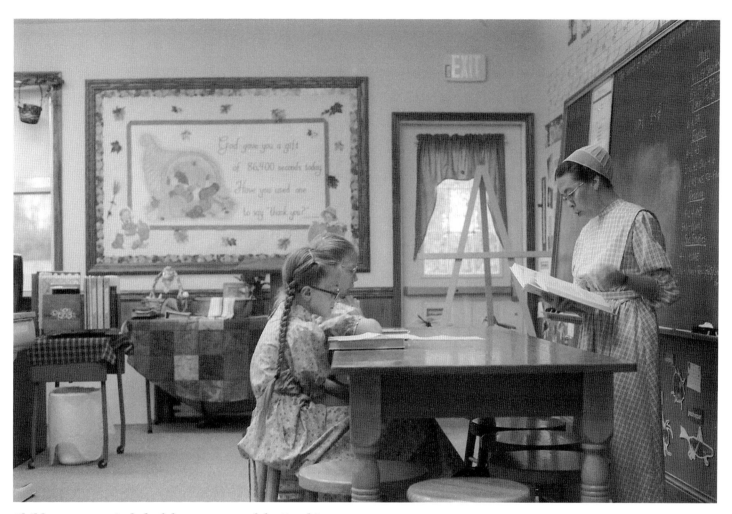

Children are reminded of the presence of the Lord in their daily lives. Aside from the teacher's instruction and student participation where prompted, the classrooms in the Mount Pleasant School are generally very quiet. *2015.*

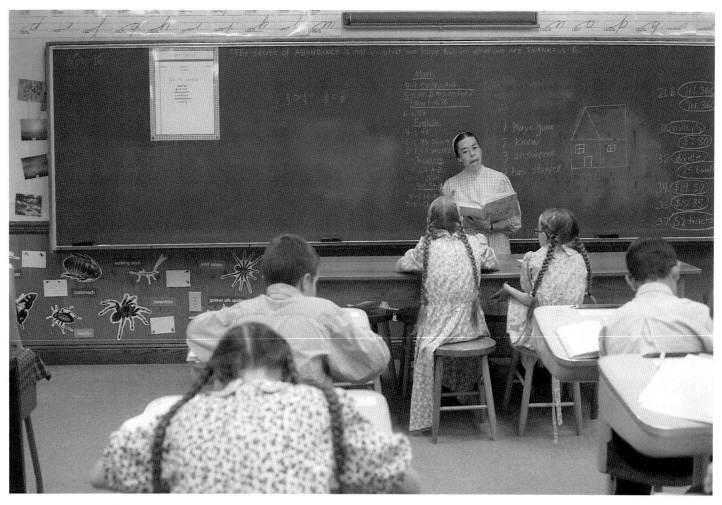

Teachers—and indeed all church members—are discouraged from pursuing institutional higher education because of its emphasis on secularism and humanism. In the Mount Pleasant community, teachers are gifted members of the church who may have moved to the community from afar in order to work at the school. They attend church-based conferences throughout the year to build on and improve their teaching skills, as well as share ideas with other teachers. *2015.*

Emphasis in Mennonite education is placed on subjects with a practical application to daily life, such as mathematics and financial literacy. These skills are put to good use in managing businesses and agricultural ventures.

In order to maintain separation of church and state, Christian day schools do not accept government subsidies. Periodically, the Sunday collection at Mount Pleasant Mennonite Church is for the school. Monies go to fund the school and pay teacher salaries. *2015.*

All books for the church and school libraries are approved by the local ministry at Mount Pleasant. Books may be rejected if they contain information that is contrary to Mennonites' understanding of Bible teachings, such as references to worldly forms of entertainment (television, radio, or mainstream media, for example) or the theory of evolution. *2015.*

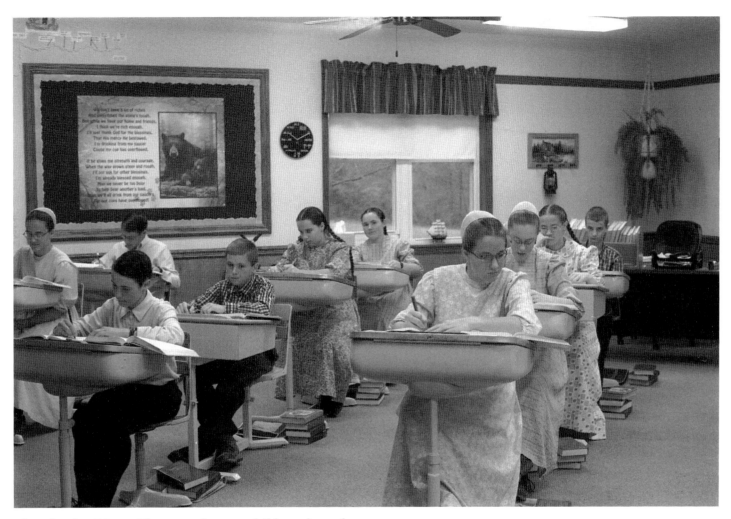

The school at Mount Pleasant educates children through grade ten. By then, students have usually exceeded the standard of education taught in American public schools and are therefore able to work for businesses within the community and to manage their finances and their own home, should they live on their own or marry. *2015.*

In like manner also, that women adorn themselves in modest apparel, with shamefacedness and sobriety; not with broided hair, or gold, or pearls, or costly array; But (which becometh women professing godliness) with good works.

1 Timothy 2:9–10

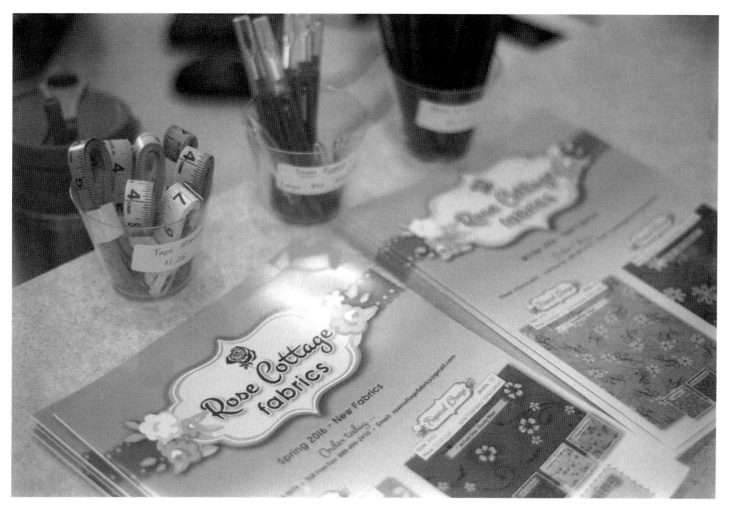

At time of photographing, Rose Cottage Fabrics was a store run by church member Esther Detweiler. Pamphlets and emails were sent out to those on mailing lists when new fabrics became available or were put on sale. The store catered to the needs of women who sew much of their own clothing. Esther received many mail orders and was the main source for dress fabric within the church community. *2016*.

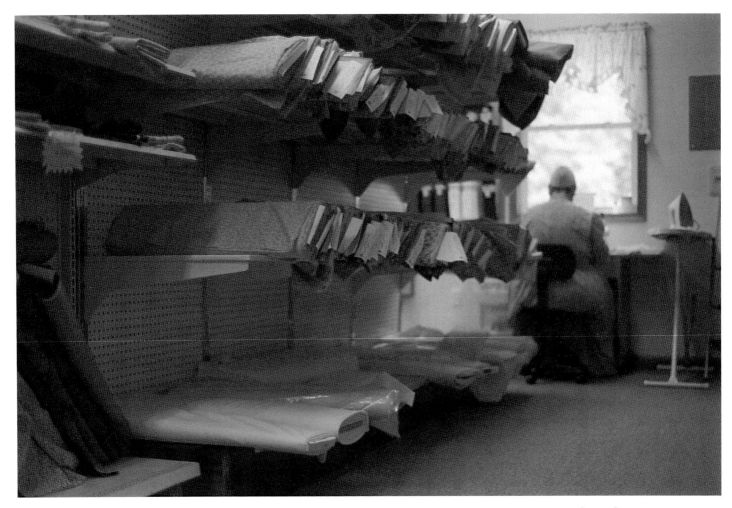

In adhering to strict standards of dress, the pattern repeats—defined as the distance between one point of the design and the exact point where it begins again—are no greater than one inch. The creation of one's own clothing overcomes the problems associated with worldly apparel, adheres to the scriptural sense of modesty, and visually represents the Mennonites' separation from the world.

Many Mennonite women are talented seamstresses. In forgoing higher education, they are largely taught by their mothers and other women within the community. They are knowledgeable in a number of advanced garment-making techniques, such as inserting an invisible zipper (in the back of their dresses) and pattern matching, where they match patterned fabrics, such as plaids, at the seams and back zippered areas of their dresses. *2016.*

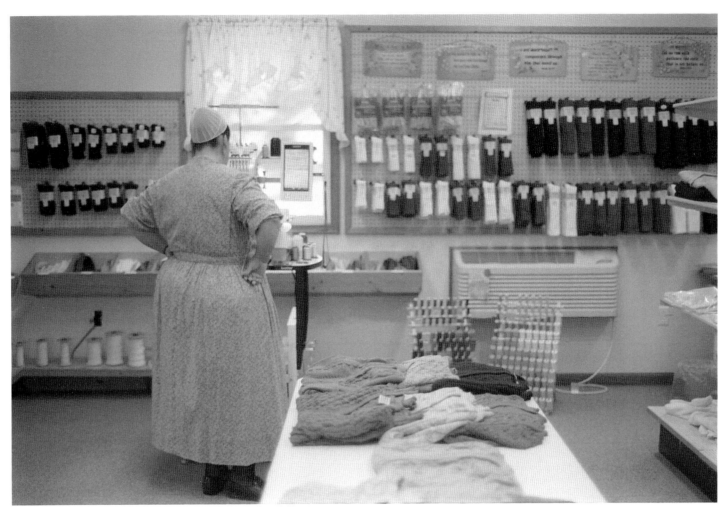

Esther Detweiler oversees her computer-operated embroidery machine. While the Internet is used cautiously among Mennonites, computers and computer-operated machinery are acceptable within businesses and work. Computers can be found in many homes and are used to save and print photographs, to email family and friends, and to type documents. "Screen time" as entertainment, though, is strictly avoided. Videos are generally not acceptable, but exceptions may be made where demonstrative instruction is being provided. *2016*.

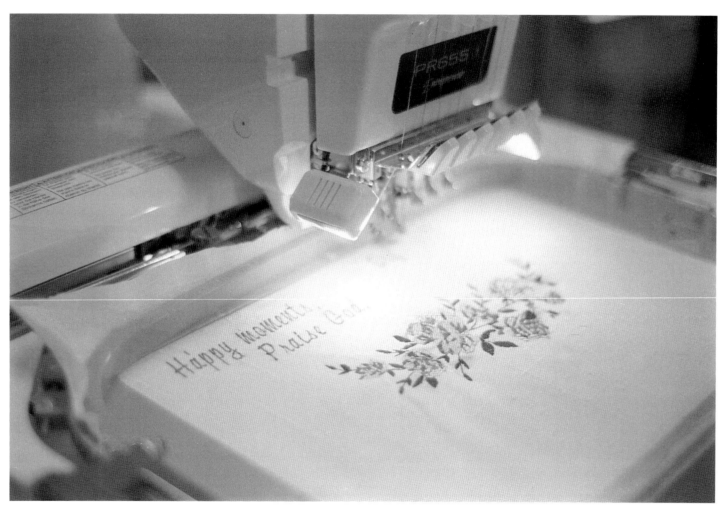

"Happy moments, Praise God." A wall hanging is embroidered for decor intended for Gerald and Rosene Martin's home. *2016*.

And God said, Let us make man in our image, after our likeness: and let them have dominion over the fish of the sea, and over the fowl of the air, and over the cattle, and over all the earth, and over every creeping thing that creepeth upon the earth.

Genesis 1:26

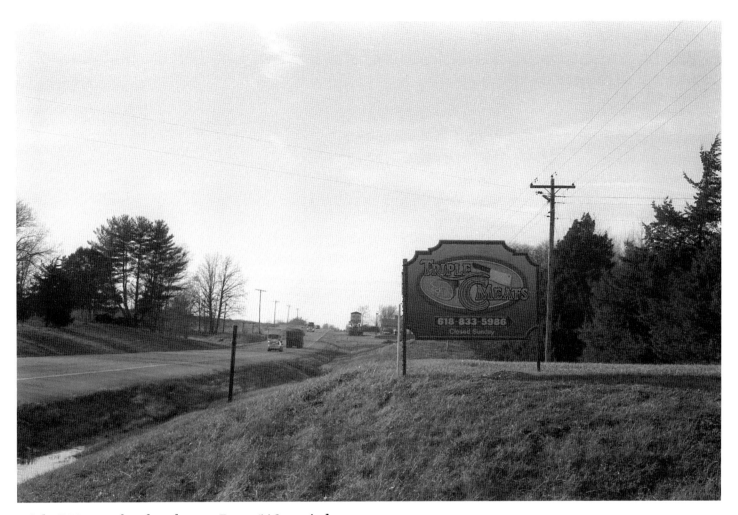

Triple C Meats, a butcher shop on Route 146, reminds customers that it does not conduct business on Sunday, the Lord's day. In accordance with the teaching of Creation, the seventh day (Sunday) is used as a day of worship and rest, and as such all Mennonite businesses are closed. The shop offers the slaughter and processing of farm animals, as well as the processing of game meat according to customer specifications. *2015.*

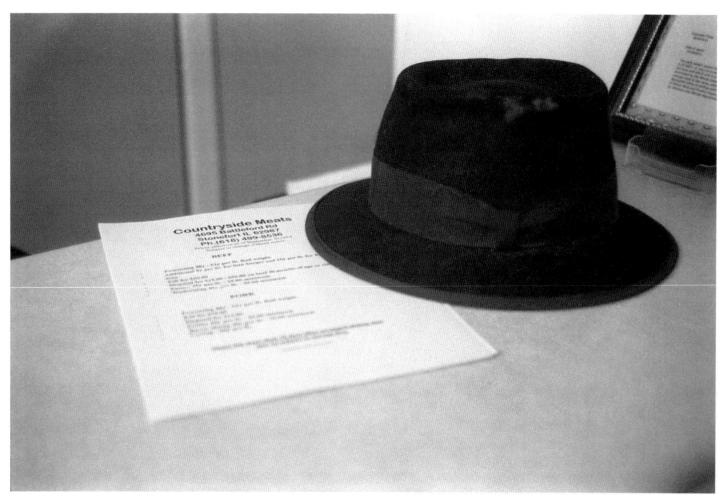

A hat is worn as part of the men's "plain" attire, shown here at Countryside Meats in Stonefort. *2014.*

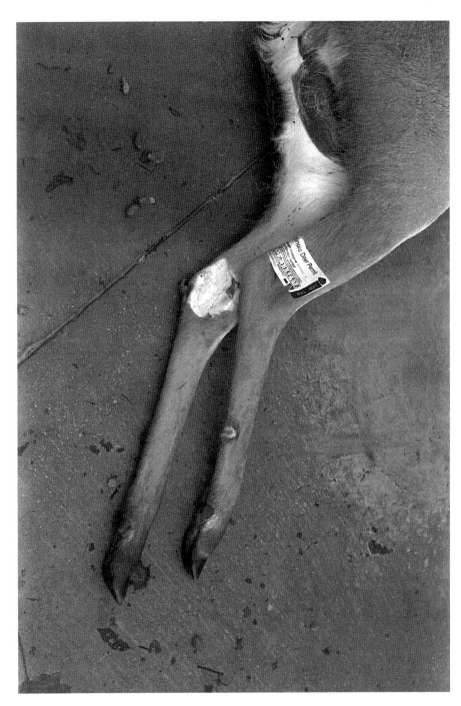

A deer is successfully hunted on the opening day of shotgun season. All animals shot are tagged, in adherence with state of Illinois law. *2019.*

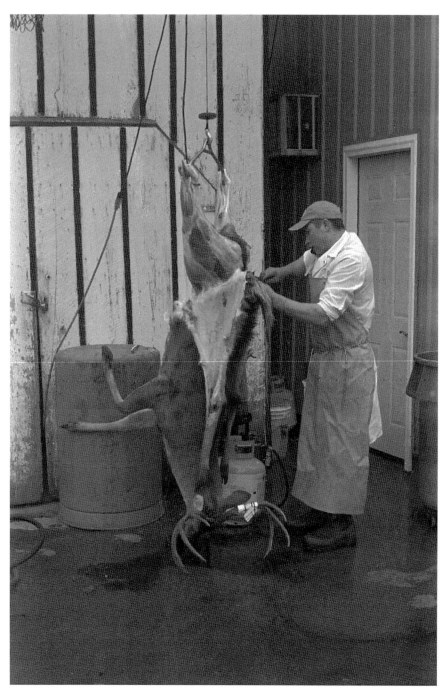

Deer are skinned before being taken inside Triple C Meats for processing. *2019.*

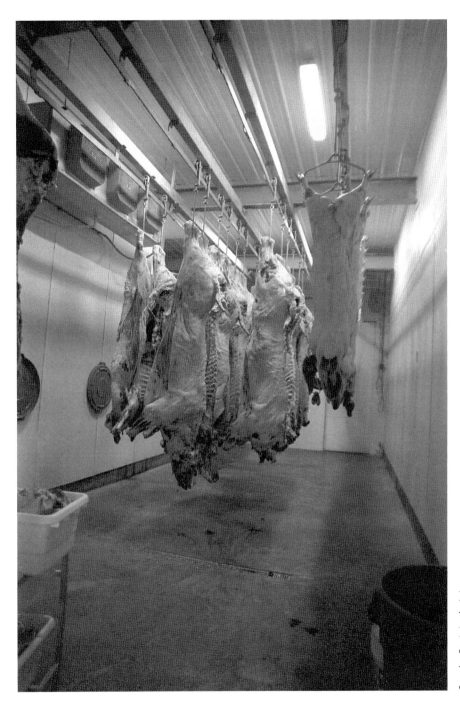

Beef and pork hang ready for processing in the walk-in refrigerator at Triple C Meats. During deer season, the refrigerator is left open on Sundays so that hunters may drop their deer off when business is closed in observance of the Lord's day. *2015.*

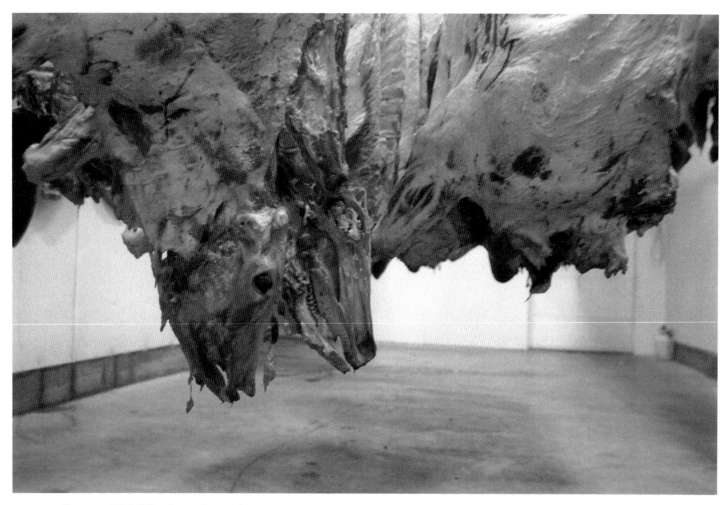

In accordance with biblical teachings (as in Genesis 1:26), meat is considered an essential part of one's diet. Many families raise their own livestock, including pigs and cattle, for meat. Chickens are often kept for their eggs and sent for butchering once they are no longer productive layers. *2015.*

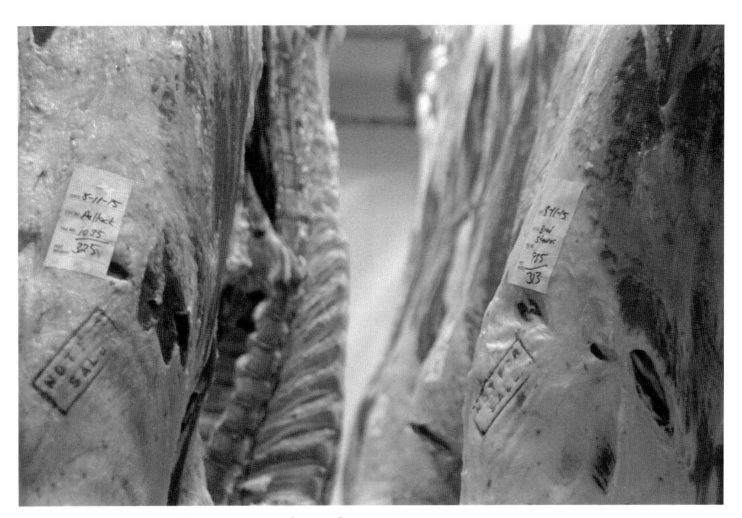

Due to strict laws, much of the meat processed at Triple C Meats cannot be sold commercially. Instead, it is for the personal consumption of the customers who commission the slaughter and processing of their animals. *2015.*

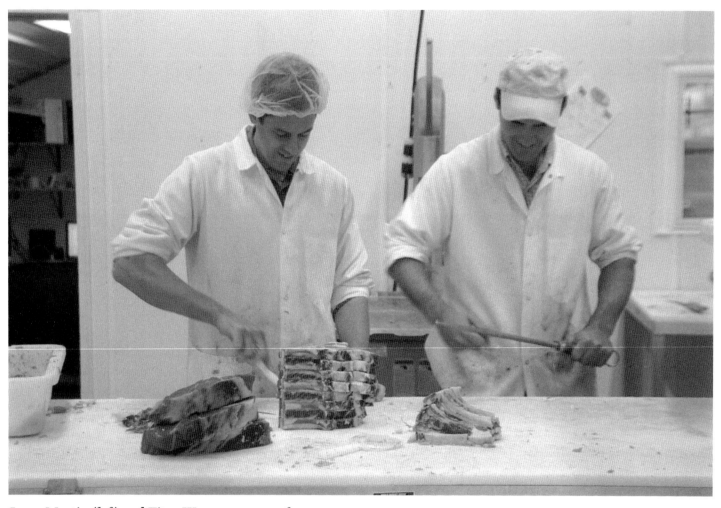

Jason Martin (*left*) and Titus Weaver, owners of Triple C Meats, work with a team of employees from the Mennonite community and the nearby towns of Anna and Dongola. The bedrock of Mennonite-owned businesses is honesty and consideration for their employees and customers. *2015.*

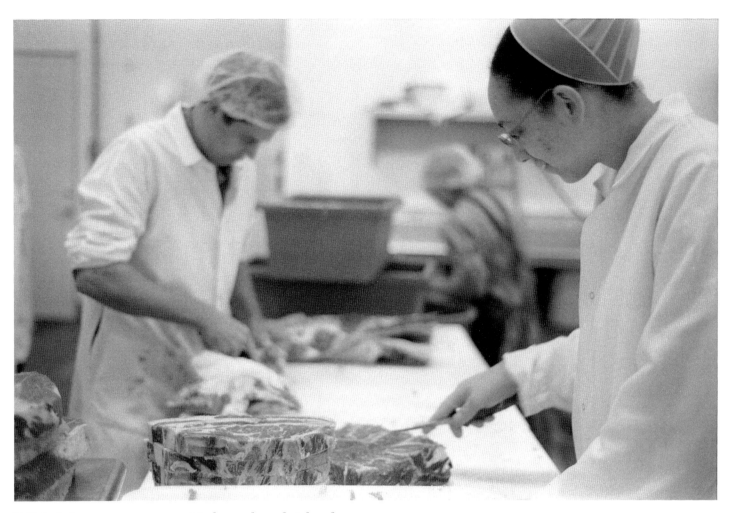

Felicia Lehman prepares meat to be packaged. A head covering is worn in recognition of the divine order of headship as it is taught in 1 Corinthians 11:1–16. All sisters (baptized female church members) must wear an appropriate veiling at all times for consistent testimony that they accept their position as Christian women. Those who have not yet joined the church wear their hair in braided pigtails. A girl's hair will never be cut and as a result may grow so long as to almost touch the floor. *2015*.

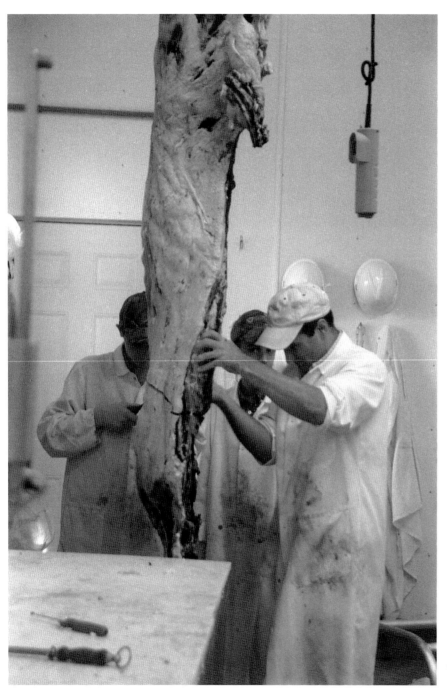

Jason Martin's son Brenton peeks at the camera while preparing meat. *2015*.

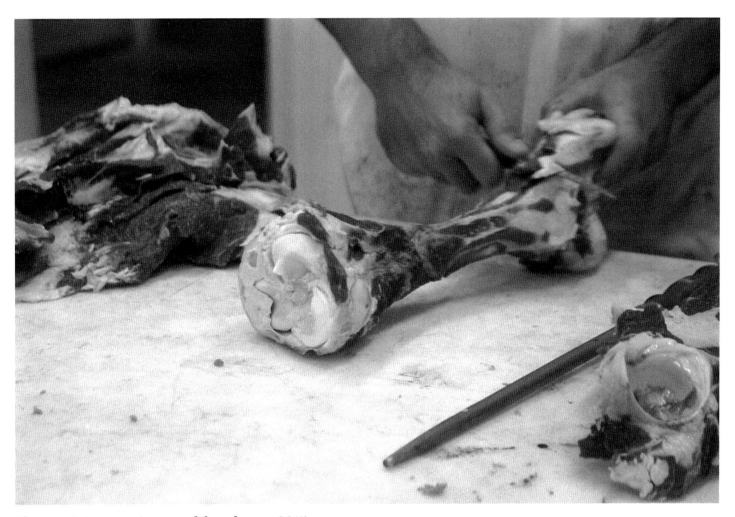

The remaining meat is scraped from bones. *2015*.

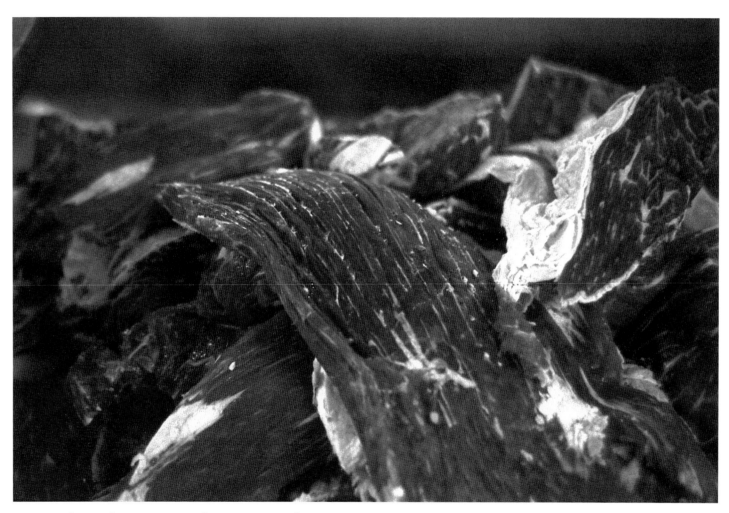
Processed meat from Countryside Meats, Stonefort. *2014.*

Seest thou a man diligent in his business?
he shall stand before kings; he shall
not stand before mean men.

Proverbs 22:29

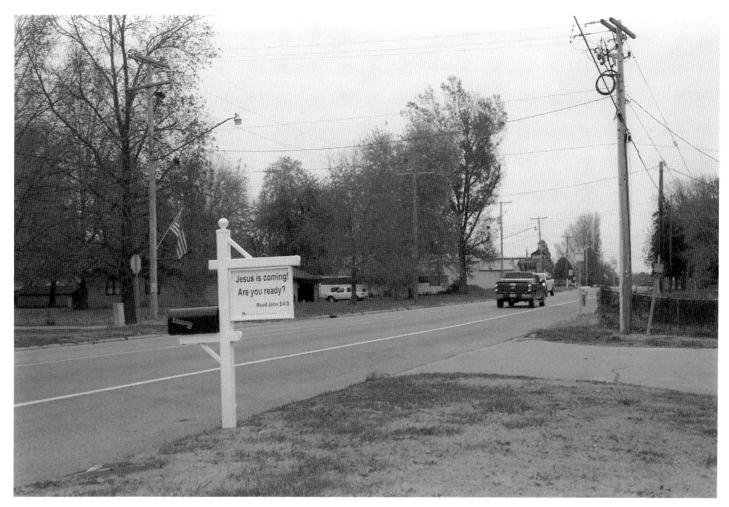

Customers are reminded of the Mennonite belief in Jesus's return as they enter and exit the parking lot at Village Pantry in Carrier Mills. In addition to roadside signage (shown on page 12), Bible-based messages and scripture are commonly found on roadside mailboxes of church members' homes and Mennonite-owned businesses as part of their evangelizing efforts. *2014.*

Handmade bird feeders hang for sale outside Village Pantry. In addition to groceries, a deli counter, and baked goods, the store offers a selection of high-quality items of wood construction, for which many so-called plain communities are well known. *2014*.

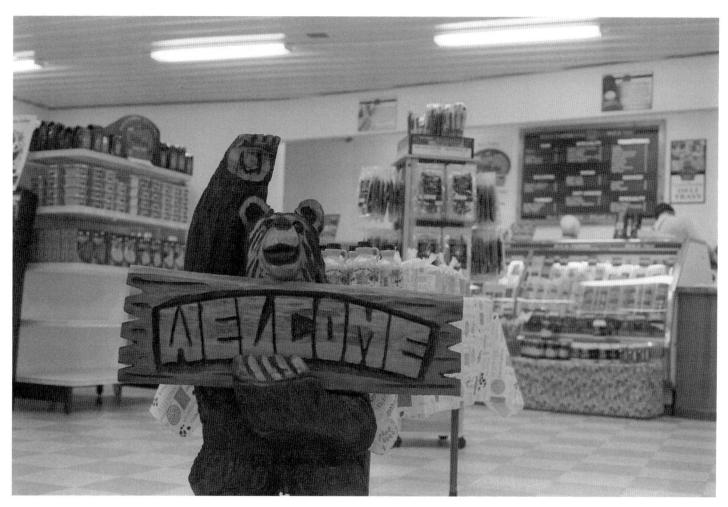

A carved wooden bear welcomes customers to Village Pantry, which, at time of photographing, was owned and operated by Jonathan and Regina Beachy, who were members of the Stonefort/Carrier Mills community. *2014.*

Top left: Many items needed for baking are sold at the store. Baking is an art that many plain communities are well known for; their goods are often sold at farmers' markets. *2014.*

Left: An illustration of a horse and carriage, a symbol often associated with plain communities, adorns flavoring bottles. One can presume the flavoring shown is made by a conservative Amish- or Mennonite-owned business. *2014.*

Customers at Village Pantry often purchase items in bulk, so as to get the best value for their money. Under instruction from the Bible, Mennonites appreciate being resourceful, considering the resources they have as gifts from God. *2014.*

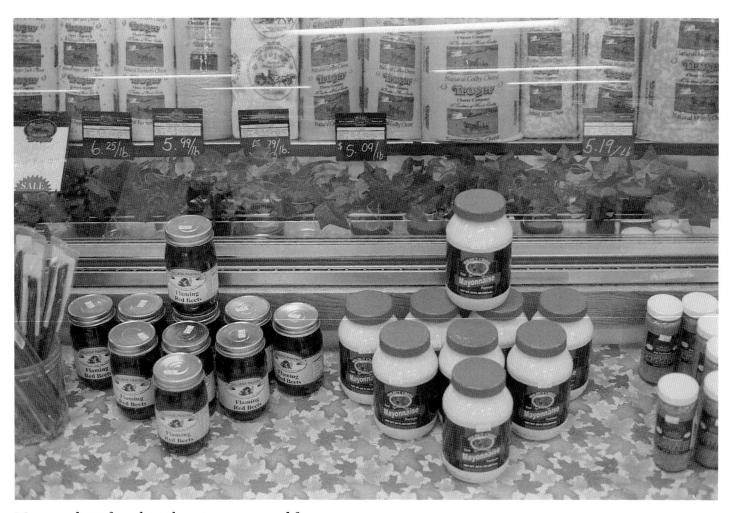

Many products for sale at the store are sourced from farms and operations run by Amish and Mennonites throughout the United States. Troyer, a familiar name within plain communities, can be seen branded on cheeses in the refrigerator. *2014.*

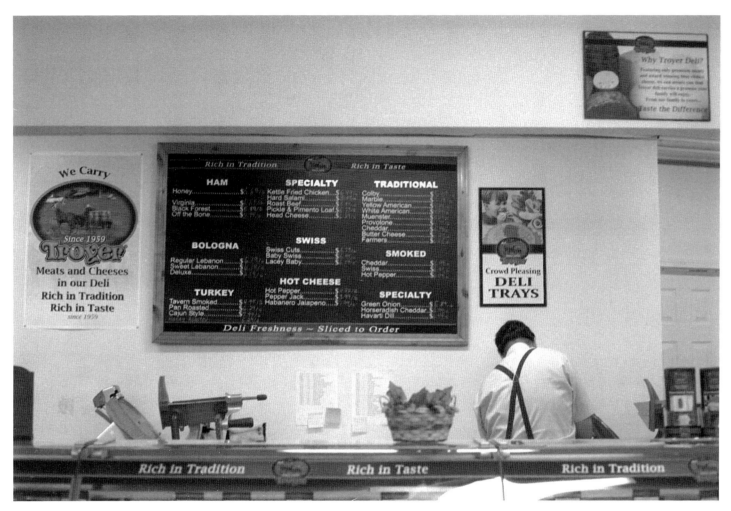

In adherence to strict codes of dress, gentlemen of the Stonefort/Carrier Mills Mennonite community wear suspenders, grow beards when married, and have cropped haircuts. *2014.*

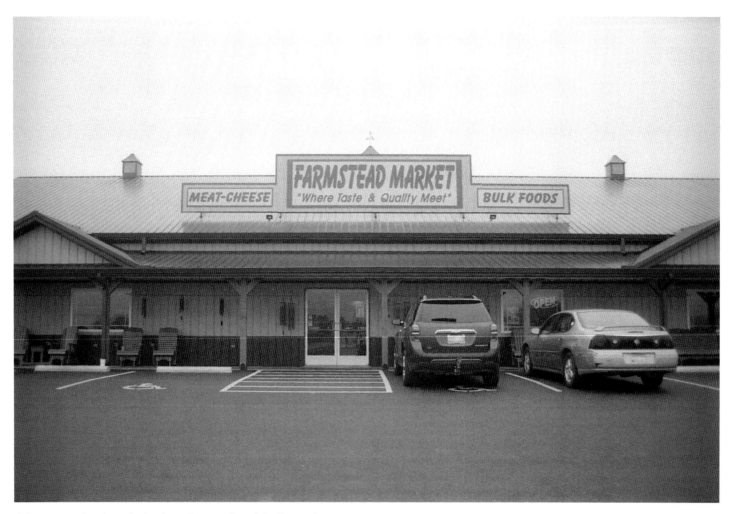

After transferring their church membership from the church in Carrier Mills to Mount Pleasant in 2017, Jonathan and Regina Beachy relocated their business along Route 146, closing Village Pantry in Carrier Mills and opening Farmstead Market in Anna. Farmstead Market is extremely popular among church families and residents of the area. *2020.*

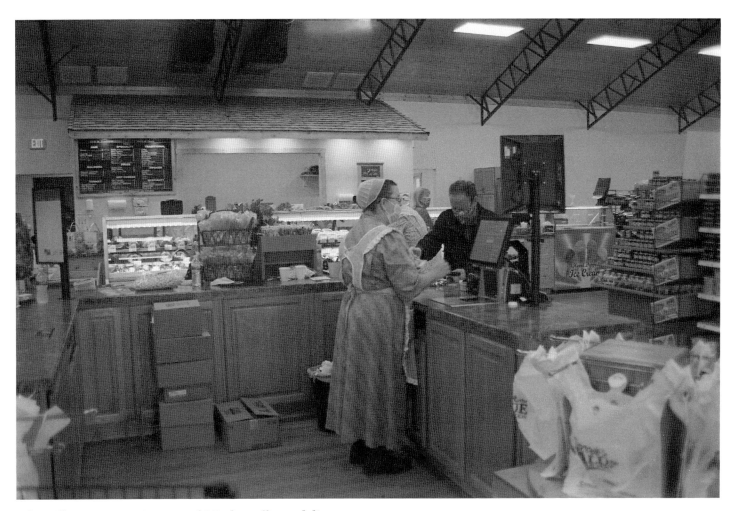

Like Village Pantry, Farmstead Market offers a deli, freshly baked goods, groceries, and many items for use within the home, such as recipe books. *2020*.

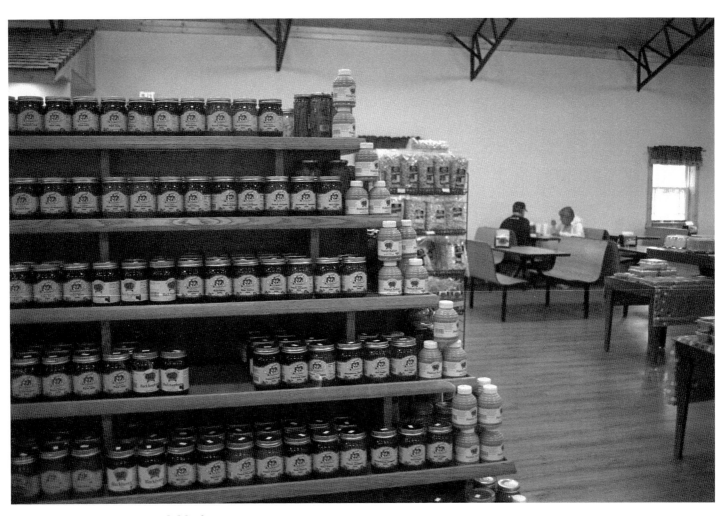

A small dining area is available for customer use at Farmstead Market. *2020*.

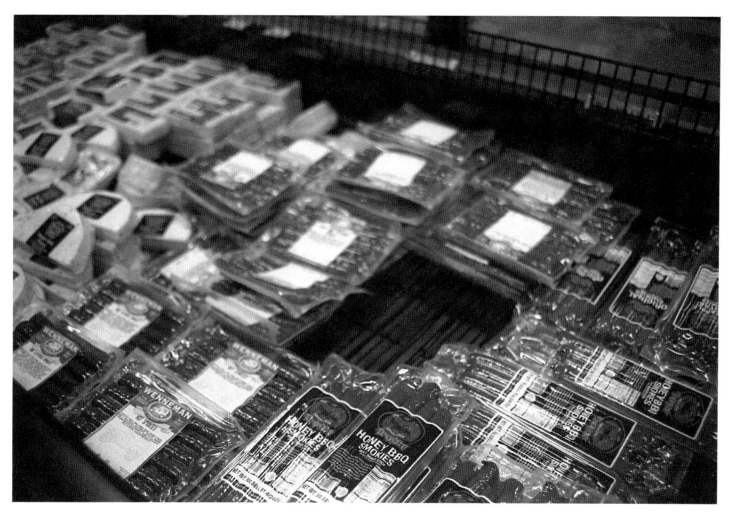

A variety of meat and dairy products are sold within the store. *2020*.

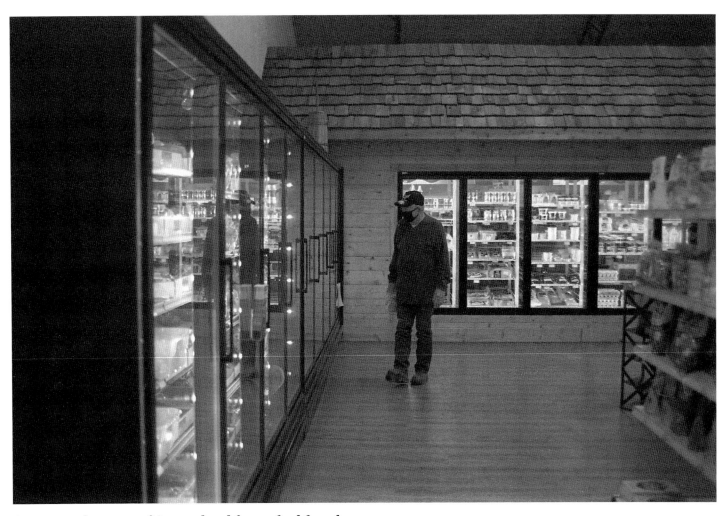

A customer browses refrigerated and frozen food for sale at Farmstead Market. *2020.*

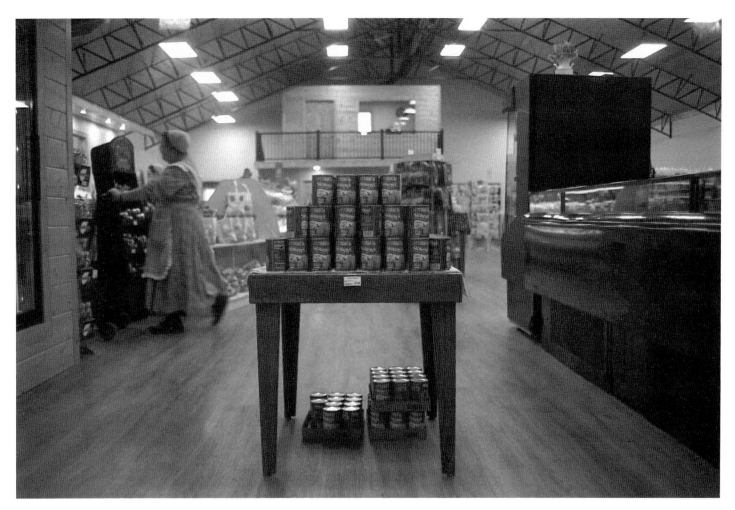

Farmstead Market employs many church members, mostly single women. Many Mennonite families within the community frequent the store for their groceries, as they prefer to support businesses owned and operated by Christians. Church members will use other plain-owned businesses, in all aspects of life, whenever possible, whether local or farther afield. In my own experience, I have found all Mennonite-owned businesses to be extremely trustworthy and very efficient. *2020.*

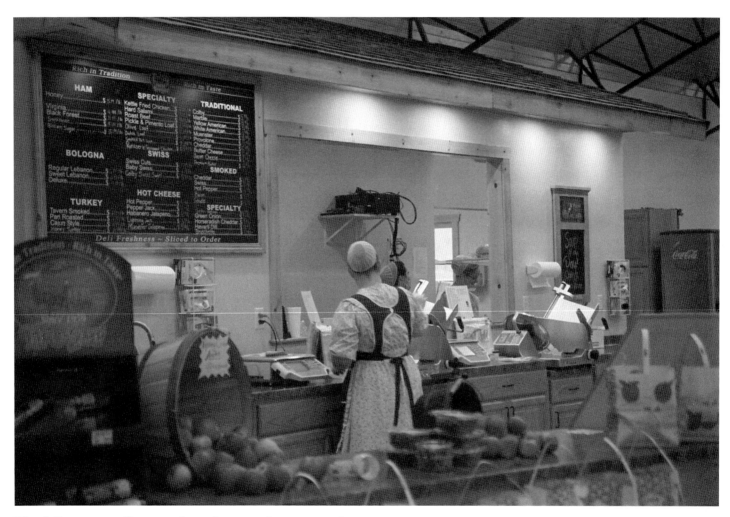

The deli counter offers a variety of meats, cheeses, snacks, and sandwiches, which are a popular choice for lunches for many workers in the area, including police officers and other first responders. *2020.*

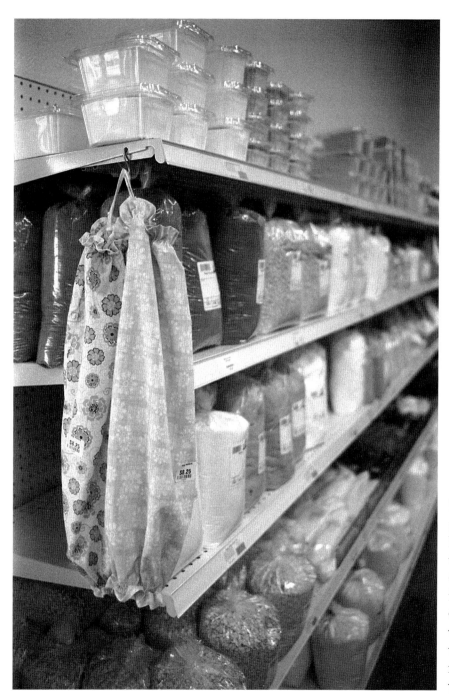

Many household items are available for purchase within the store, including these handsewn grocery bag holders. In seeing their homes and possessions as gifts from God, Mennonites consider cleanliness an important mark of respect to the Lord. Children as young as three help their mother with housecleaning; washing dishes, tidying up, and sweeping the floors are tasks that may be assigned to youngsters, who are eager to help out where they can. *2020.*

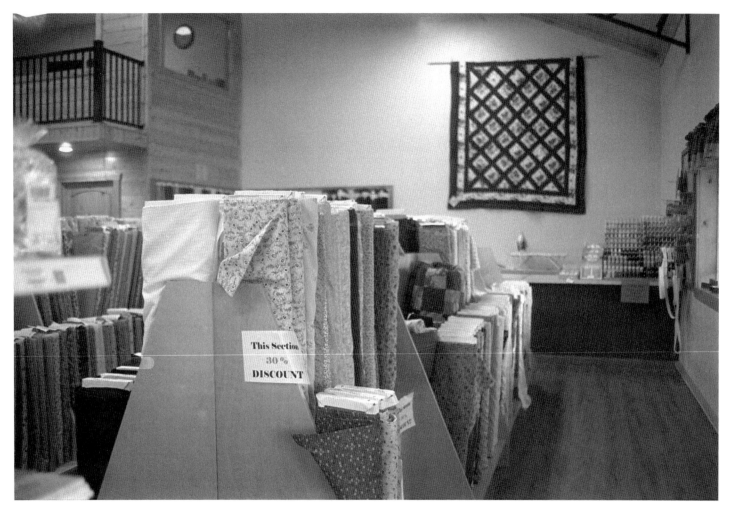

Esther Detweiler (shown on pages 59, 60, and 73), who previously taught school and owned Rose Cottage Fabrics, is presently an employee of Farmstead Market, where all the items previously for sale at her small store are now sold. Many church families jointly own businesses together and may buy businesses from different families or plain communities, sell businesses to other families or communities, or relocate businesses to other plain communities within the United States. *2020*.

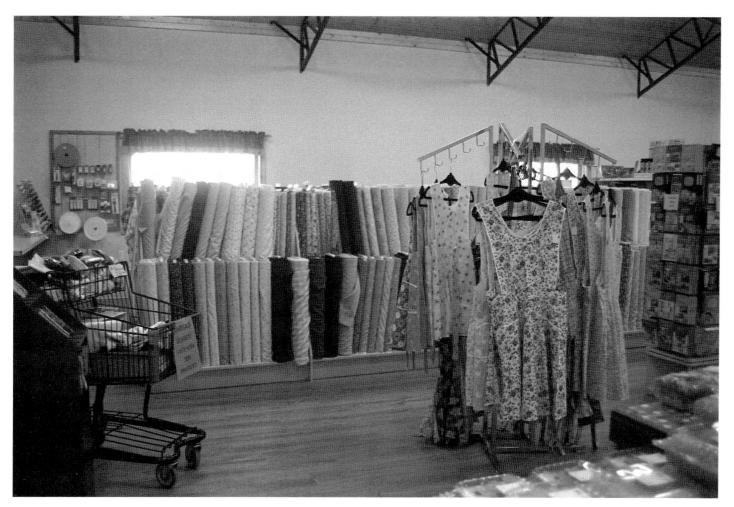

Handsewn pinafores, made by a lady within the community, are offered for sale at Farmstead Market. They are used daily when cleaning and cooking within the home. *2020.*

This is my commandment, that ye love one another, as I have loved you. Greater love hath no man than this, that a man lay down his life for his friends. Ye are my friends, if ye do whatsoever I command you.

John 15:12-14

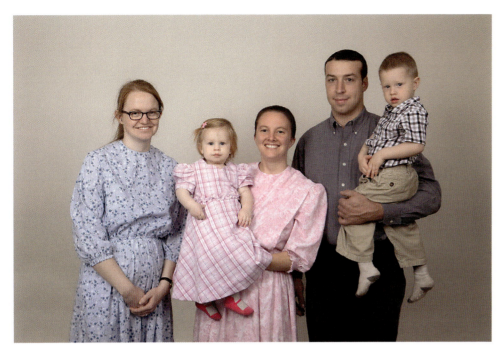

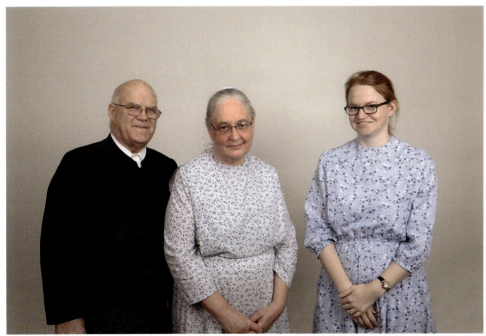

Top left: Josh and Miriam Martin, shown here with their children, Alex and Brianna, and me. I am truly grateful for the countless meals, evenings of Bible study, and times of fellowship that they provided; they have made my sense of spirituality what it is today.

Left: Glen and Wanda Weaver with me. I am thankful for their generous hospitality, both as I was living in southern Illinois and since my move north. I am grateful for the friendship and for the way they taught me so many of the biblical principles and practices of everyday Christian living. Their consistent acceptance of God's will in their lives is truly inspiring.

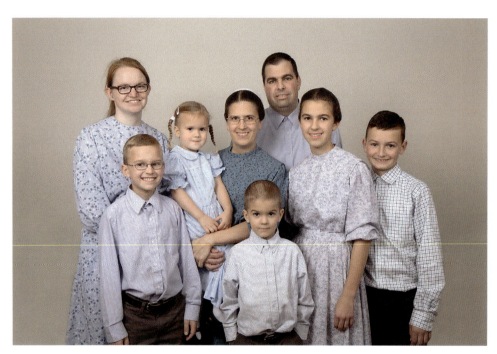

Gerald and Rosene Martin, shown here with their children (*left to right*), Michael, Jennalee, Kenton, Rosalyn, and Brian, and me. It has always been a joy working within the Martins' home and with their children. I have so many fond memories of reading the boys stories and caring for Jennalee as a baby! A special thank you goes to Gerald for making these last three photographs.

The dress I am wearing in these pictures is the one gifted to me by Ruby Weaver, who was serving at a mission in Togo, Africa, at the time these portraits were made. I thank her kindly for this gift, which has inspired my keen interest in sewing more dresses, other personal clothing, and items for my home. May the Lord bless her and her family's work as they serve in the mission field.

Formal portraits and group/family photographs are shared as a celebration of friendship or an anniversary, as friendly messages announcing the birth of a child or home move, or as a "thank you" for wedding gifts. They are usually posted somewhere within the home by a female housemaker: on notice boards, on the fridge, or adorning the wall. They may come from friends and family members from the local congregation or throughout the United States and Canada or from those serving farther afield on mission work throughout the world. To me, such photographs represent the humbling sense of unity with others, Christian kindness, and the deep respect that I have consistently experienced in all my interactions with the Mennonite communities of Mount Pleasant and Stonefort/Carrier Mills.

NOTES

BIBLIOGRAPHY

Notes

FOREWORD BY LIZ WELLS

1. See Gerard C. Wertkin, *The Four Seasons of Shaker Life* (New York: Simon and Schuster, 1986). Photographs by Ann Chwatsky.

2. Robert Frank, *The Americans*, for which all pictures were taken in 1955–56, was first published in 1958 by Robert Delpire, and then republished by First Grove Press in 1959, with an introduction by Jack Kerouac. Republished by Steidl, Germany, in 2008.

3. Estelle Jussim, "The Eternal Moment: Photography and Time," in *The Eternal Moment* (New York: Aperture, 1989), 49. Jussim was a distinguished historian of photography, and her book *Slave to Beauty* won the New-York Historical Society's prize for distinctive achievement in the history of photography.

PREFACE

1. Smith, *Mennonites in Illinois*, 19.

2. All scripture references are to the King James Version.

3. Eastern Pennsylvanian Mennonite Church, *Statement of Christian Doctrine and Rules*, 12.

4. Goodnough, "Quiet in the Land."

PHOTOGRAPHS

1. Eastern Pennsylvania Mennonite Church, *Statement of Christian Doctrine and Rules*, 4.
2. Eastern Pennsylvania Mennonite Church, 15.
3. Eastern Pennsylvania Mennonite Church, 22.
4. Eastern Pennsylvania Mennonite Church, 31.
5. Eastern Pennsylvania Mennonite Church, 17.
6. Eastern Pennsylvania Mennonite Church, 18.
7. Eastern Pennsylvania Mennonite Church, 19.
8. Reuber, *21st Century Homestead*, 27.
9. Reuber, 27.
10. Eastern Pennsylvania Mennonite Church, *Statement of Christian Doctrine and Rules*, 14.
11. Eastern Pennsylvania Mennonite Church, 14.

Bibliography

Eastern Pennsylvania Mennonite Church. *Statement of Christian Doctrine and Rules and Discipline of the Eastern Pennsylvania Mennonite Church and Related Areas.* 10th statement ed. Pa.: Eastern Pennsylvania Mennonite Church, 2014.

Goodnough, Bob. "The Quiet in the Land." Flatlander Faith. November 16, 2021. https://flatlanderfaith.com/2021/11/16/the-quiet-in-the-land-2/.

Reuber, Brant. *21st Century Homestead: Beekeeping.* Morrisville, N.C.: Lulu.com, 2015.

Smith, Willard H. *Mennonites in Illinois.* Scottdale, Pa.: Herald Press, 1983.

Jane Flynn's work appears frequently in professional exhibitions in the United States and internationally, the most recent being the Montgomery Photo Festival, presented by the Society of Arts & Crafts. She is currently practicing photography and specializes in documenting those in contemporary American society who may not typically be considered as underrepresented but are not well—or fairly—represented within art and media today. Much of her work is available online at https://www.janeflynnphotography.com/.